Women of New Mexico

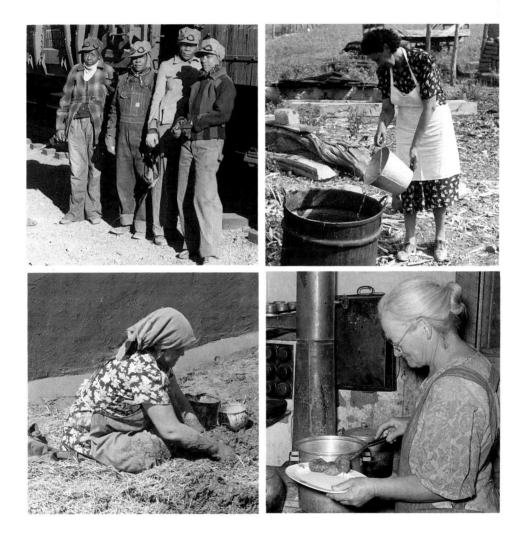

Women of New Mexico

Depression Era Images

Compiled and Edited by
MARTA WEIGLE

Ancient City Press
Santa Fe

The New Deal and Folk Culture Series

First Edition
Designed by Mary Powell
Cover design by Connie Durand

Library of Congress Cataloging-in-Publication Data

Women of New Mexico : depression era images / edited by Marta Weigle.
 p. cm. — (The New Deal and folk culture series)
 Includes bibliographical references and index.
 ISBN 9-941270-55-6 (clb.) — ISBN 0-941270-54-8 (pbk.)
 1. Rural women — New Mexico — Social conditions — Pictorial works. 2. Rural women — New Mexico — History — Pictorial works. 3. New Mexico — Rural conditions — Pictorial works. 4. Depressions — 1929 — New Mexico — Pictorial works. I. Weigle, Marta. II. Series.
HQ1438.N55W66 1993
305.42′0972 — dc20 88-72049
 CIP

10 9 8 7 6 5 4 3 2 1

CONTENTS

PREFACE

In an October 1941 *U.S. Camera* article, Farm Security Administration photographer Russell Lee called himself "a photographer hired by a democratic government to take pictures of its land and its people . . . accumulating a file . . . which may endure to help the people of tomorrow understand the people of today, so they can carry on more intelligently." When asked to explain his July 1940 fieldwork in Pie Town, New Mexico, Lee replied: "To the people of Pie Town I said with exact truth, 'I want to show the rest of the country how you live.'" This collection of representative visual and verbal images of women, which Lee and other New Deal photographers and writers preserved, was conceived in a similar spirit: to indicate how some New Mexican women lived before and during the 1930s and early 1940s and to make a very modest contribution to the study of rural women in American history along the lines suggested by historian Joan M. Jensen in her *Promise to the Land: Essays on Rural Women* (1991).

Primarily a collection of eighty-six Farm Security Administration (FSA) photographs, *Women of New Mexico: Depression Era Images* also includes twenty-five excerpts from the WPA New Mexico Federal Writers' Project (later Writers' Program) manuscripts. The FSA photographs were chosen from over five thousand New Mexico images in the Library of Congress for their informative content and heuristic value. The written texts—vividly impressionistic, anecdotal, or biographical sketches—have been selected from several thousand manuscripts among the New Mexico Federal Writers' Project/Program files at the Library of Congress and in Santa Fe repositories at the Museum of New Mexico and the State Records Center and Archives.

Both the photographic and the written records are presented as equivalent, self-contained images. These visual portraits and verbal sketches are grouped by subject in the chapters. Women are shown participating in activities surrounding the home, water and washing, food and cooking, education and welfare, sewing and weaving, commerce, and celebration and ritual.

In the appendix are summary accounts of and selected references to the initiating federal projects (Farm Security Administration, Federal Writers' Project, Writers' Program) as well as biographical sketches of the photographers and writers whose work is represented herein. An annotated bibliography of references cited throughout this collection and additional, selected material on the New Mexico New Deal projects concludes the volume.

The major work for this and my other, similar editions was made possible by a 1979-81 grant from the National Endowment for the Humanities to myself and William Wroth, then of the Taylor Museum of the Colorado Springs Fine Arts Center, to investigate "Governmental Support of the Arts in New Mexico, 1933-1943" (RS-00056-79-0589). Then and since, Will

has proved a good friend and excellent colleague in these and other Southwest studies.

The staffs of the New Mexico State Records Center and Archives, Santa Fe; the History Library, Museum of New Mexico, Santa Fe; and the Manuscript Division, the Prints and Photographs Division, and particularly the American Folklife Center in the Library of Congress have always provided gracious and efficient support. I would especially like to thank Gerry Parsons of the American Folklife Center for all his hospitality, enthusiasm about the materials, and insights into the workings of federal cultural conservation projects.

Two friends have remained staunch since graduate study in folklore and folklife at the University of Pennsylvania. Nan Martin-Perdue and Chuck Perdue, now at the University of Virginia, have worked long and well on New Deal projects in Virginia, ably demonstrating the value of these materials in the study of folk culture, ethnohistory and rural life.

This volume is part of the New Deal and Folk Culture Series published by Ancient City Press, and I would like to dedicate it to Robert F. Kadlec and Mary A. Powell, my partners in publishing. Bob started the Press in 1961, when I first met him, and he later introduced me to Lorin (Lorenzo) W. Brown, two of whose Writers' Project manuscripts appeared in a 1972 Ancient City Press publication which I edited, *Echoes of the Flute.* The present collection was Mary's idea, first suggested during various 1980s trips to Washington that included stops to examine Library of Congress holdings, and her skills in design, production and marketing have enhanced it considerably. I am indebted to both these friends, whose good work has given me and others the opportunity to participate in the challenging task of publishing and keeping regional books in print.

INTRODUCTION

We [Farm Security Administration photographers] fulfilled the informational needs, meticulously photographing soil washed from improperly cultivated fields, and improperly canned green beans. But in between these official duties we worked for Roy Stryker whose concerns were the "good life" and American rural culture. He consistently challenged his team to go beyond the accepted limits of photography to record the extra-sensory nuances of environment. Stryker was always pushing for a fresh and original regional view. He was an unusual scholar—part geographer, part agricultural economist, part American historian. And beneath all this, Roy was a cowboy from Colorado!

... What we gathered in eight years was a unique visual geography of America covering every element of rural and small town life—participant observation, photographs made over a collaborative human bridge. How many family meals are there in the FSA file, from Acadian Maine to Hispanic Southwest, with an empty plate in the foreground, each waiting for the photographer to sit down?

—John Collier, Jr., 1986 (in Wood 1989:7-8).

Try to make the readers see the white mid-summer haze, the dust that rises in unpaved New Mexico streets, the slithery red earth roads of winter, the purple shadows of later afternoon, the brilliant yellow of autumn foliage against brilliant blue skies, the pseudo-cowboys in the tourist centers, the blank-faced Indians who are secretly amused by white antics, the patched and irregular walls of the older adobes; make him understand the social cleavages and jealousies, the strangely rotarianized "Indian dances," the life of the transplanted Oklahomans, Texans, Mexicans, Greenwich Villagers, and so on. (June 13)

We want the type of visual description that [John] Steinbeck would give— that is, descriptions of the types of buildings common to smaller New Mexican towns, mention of color, smells, sounds, signs, and above all, of the types of people seen along the streets. (July 20)

—Federal Writers' Project director Henry G. Alsberg to New Mexico FWP director Aileen O'Bryan Nusbaum, 1939 (in Weigle 1989:64).

Both photographic and written New Deal documentary projects were informative, evocative and provocative. Farm Security Administration photographers showed mundane work and conditions in rural areas and small towns and humanistic portraits of people there engaged in routine and special activities. A primary task of the Federal Writers' Project (later Writers' Program) was to produce a comprehensive state guidebook for what became the American Guide Series, and in the course of that work much biographical, ethnohistorical, social and local historical, ethnic and folkloric material was collected. No special, federally instigated projects specifically documented women, but some of the photographers and writers were themselves women, and women's lives and work figure in many of the photographs and manuscripts.

Roy E. Stryker, who directed the photographic section of the Farm Security Administration (FSA—earlier, the Resettlement Administration; later, the Office of War Information), "never singled out [New Mexico] . . . as a state deserving in-depth [rather than incidental or random] fieldwork during the thirties, mainly because New Deal efforts centered around the South, the Midwest, and California [and he] had no budget to send photographers to marginal, sparsely populated states like New Mexico until the later years of the project" (Wood 1989:4). Although Arthur Rothstein and Dorothea Lange earlier had touched on New Mexico scenes, it was not until late 1939 and early 1940 that Stryker urged Russell Lee to make a more thorough documentation of the Southwest (Wroth 1985: 133). Still, the Indian Southwest received scant notice, for, as John Collier, Jr., remembered in 1985: "Basically, Stryker was not interested in Indians and their problems" (Wood 1989:7). Anglos and, to an extent after 1939, Hispanos occupied FSA attention.

Russell Lee's series on Pie Town homesteaders happened by chance when the unusual name caught his attention on a map, as he indicated in a 1985 interview:

> So we decided to take a little detour [on the way to Peñasco]. We had just done Texas and we had this big shoot [of Hispanic villages] coming up. We thought we'd go over and relax, you know, there it was on the Continental Divide. Pie Town turned out to be this wonderful frontier town, much like the frontier towns of a century ago. I got very excited about it because, it seemed to me, this was the sort of place that had unalterably molded the American character. Roy said, "Go ahead and do it and while you're there, you might as well check out mining." So that's how I covered Mogollon, too. (Wood 1989:10)

The decision to send him on a "Spanish-American story" to the northern Hispanic villages of Peñasco and Chamisal had come after a September 1939 trip to Taos, where he reported to Stryker having taken

> pictures of the life around a Spanish-American home—mostly the duties of a house wife—from feeding the rabbits, gathering vegetables in the garden [Plate 29], making soap at home [Plates 19-23], preparing tortillas, chile peppers [Plates 30-31] and the like. Yesterday we went to another place where the Grandmother (age 75) went through all the motions of baking bread in an outdoor oven [Plates 41-48] Also got pix of their house—inside and out—it was one of the neatest I have been in.

The people are really grand around here—but I sure wish I had a knowledge of Spanish. (in Wroth 1985:133)

Stryker hoped to combine Lee's work with an expert's interpretive text to publish a photographic essay, but war intervened and the project was shelved. More elements of the Taos County "Spanish-American story" were documented by John Collier, Jr., in early 1943, when he also photographed Anglo ranchers and their families in the Moreno Valley.

Federal Writers' Project (FWP) director Henry G. Alsberg and later Writers' Program (WP) director John D. Newsom insisted on the primacy of collecting data for the comprehensive American Guide project with detailed volumes for each state. New Mexico FWP workers were late in completing *New Mexico: A Guide to the Colorful State* (1940), in large part because they were attracted to the state's rich folklore and ethnohistory.

One of the first proposals for the study of folklore was submitted to the FWP by native New Mexican Nina Otero-Warren and University of New Mexico president J. F. Zimmerman on December 10, 1935. They proposed that the Southwest (New Mexico, Arizona and southern California) be singled out for an organized collecting project that would include folktales, pioneer stories, cowboy songs, Spanish ballads, folk drama and place names because:

> There was a time when standardization was rampant and all efforts, social and economic, converged on the idea of making the country uniform to the point where Southwestern villages would be identical with Middletown. Our art, our literature, and our music became one. Since then, however, we have become more appreciative of the differences in the various localities of the United States. In fact, we welcome a genuine distinction as something that should be preserved. In some cases, we go too far trying to be different. The more genuine manifestation of true regional culture is embodied in the folklore production throughout the United States. The Southwest with its triple culture: Indian, Spanish, and English, offers a field to the sociologist, ethnologist, and the writer that no other part of America has to offer.
>
> The philosophy of life of regional folk is only arrived at by a study of their culture, a culture that is manifested through such things as song and poetry. There is a group of society that is fairly uniform throughout America. This group wears the same brand of shoes, eats the same foods, sings the same songs, and dances to the same music, throughout the nation. For this reason, this group is of less interest to the ethnologist. It is a person who is a product of the soil; who lives closely to it, that is able to give us the regional and varied aspect of America This is the true America that lies hidden in the Southwest, and this is the place where a collection of material which will lead us to understand these people lies ready for the folklorist, ethnologist, and anthropologist.

Otero-Warren and Zimmerman's proposal was not directly acted upon, but various folklore/life collection projects were developed at federal and state levels (Weigle 1985:xviii-xix; 1989).

Among the extant NMFWP/WP manuscripts are various pieces that directly or indirectly express nostalgia for an earlier, more benevolent way of life that contrasts to the bleak era of depression, drought and slow economic recovery. Such texts include several by Reyes N. Martínez of Arroyo Hondo, who identifies 1900 as a "watershed" or dividing line (Text 5), after which he believes cooperative village labor ceased to be usual and was fast being usurped by wage labor. May Price Mosley of Lovington writes extensively and proudly of early, pre-farm ranch life in Lea County (Texts 1, 8, 10, 12, 15) as personally experienced and as evocatively recalled by oldtimers of her acquaintance.

Women do not figure prominently in either photographic or written New Deal documentation projects, but they are certainly represented. Historian Joan M. Jensen, who also has researched the life of "New Mexico Farm Women, 1900-1940" (1991:83-96), traces a significant change:

> Farm Security Administration photographers left moving portraits of the rural women who came to symbolize the misery of the depression, the human cost. While the images certainly reflected the misery of these white sharecroppers as they moved west in search of migratory labor, the women were victims not so much of the depression or even the drought, but of a political system that insured the survival of larger, capital intensive farms at the expense of the poorer, labor intensive family farms. Such dislocation had been continuous since the late nineteenth century. Poorer families had usually become farm laborers or tenants or had migrated west to take up the remaining parcels of the public domain. Such farm families remained vulnerable to market changes, government agricultural policies that favored more wealthy farmers, and an inability to organize politically. Before the 1940s many of these families had been able to shift to other rural places Thus the 1940s, with abundant war work, quickening economy, and military mobilization proved to be a major turning point for farm families [By] the 1950s, an increasing number of farm daughters and wives found their traditional work not only devalued but also discarded. A woman's work no longer provided the margin for survival, much less success. (Jensen 1991:22-23)

To native New Mexicans like Reyes N. Martínez the changing, traditional Hispanic way of life was symbolized by the woman's shawl—the *tapalo* or *rebozo*, and he mourned its "passing" from female attire (Text 21). In *Shadows of the Past*, Martínez's sister, Cleofas M. Jaramillo further describes what happened when younger generations discarded such old traditions and began to adopt "the strangers' customs":

> The colorful *rebosos* [sic] and *tapolos* [sic] vanished. Modern music, songs and dances, have replaced the soft, musical melodies and graceful folk dances. The quiet reserve and respect has gone, which was so great that even after the sons and daughters were grown up and married, they knelt before their parents to receive their blessing and kiss their hand, and would sooner burn their hand, than to be seen by any of their elders with a cigarette in their hand.

I heard my mother's aunt once tell her: "That's one thing my sons have never done to me, is to smoke my gray hairs." The old Spanish courtesy and hospitality has also changed, to the regret of the elders, who have found it hard to get accustomed to the new ways. (Jaramillo 1941:97)

Annette Hesch Thorp, widow of N. Howard ("Cowboy Jack") Thorp, was involved in one of the last New Mexico writers' projects, and one of the few centered on women. In a November 7, 1940, letter to Writers' Program director John D. Newsom, NMWP director Charles Ethrige Minton details twelve fledgling endeavors, one to be called "Some New Mexico Grandmothers":

> We have wanted to get the life stories of several of the old crones in the villages before it was too late. Several of them have died, and they are going fast. However, there are still some of them alive whose memory is adequate and who are still able to furnish material about their long life, together with folk lore of various kinds We believe this book will be of national interest if we can get what we want, but it will be a year or more before we shall know whether we have enough material of the kind we want to justify national publication.

He describes Annette H. Thorp's fieldwork thus:

> This is very slow work, for it means many visits for the most meager results and copious immaterial conversations and strayings from the point in order to get the outline, as well as any stories about the early days. All this is in fluent idiomatic Spanish, the interviewer being an elderly woman who is sympathetic and interested; also she is free to go to any locality where the material can be obtained. She must spend hours getting acquainted and establishing a friendly relationship, getting behind walls of reserve and suspicion and establishing a kindly free exchange. (in Weigle 1983: 94, 95-96)

At least one side of this colloquial, conversational, "kindly free exchange" is expressed in the opening paragraph of an early manuscript (Text 6), submitted in October 1940:

> Women think they work now days. Pero no, they don't know what work is. The Americanos have made it so easy for them now. They would die if they had to work like she did when she was young, and strong, said Chana, a very old women who lives in the country with her granddaughter.

THE PLATES AND TEXTS

1940 New Mexico Map showing Towns and Counties mentioned in text.

READER'S GUIDE

Photograph Captions: The Farm Security Administration (FSA) photographs in the Library of Congress files display a distinct caption format, which has been followed herein. The place and date of the shot precede the identification and commentary, with the photographer's name and the Library of Congress plate number at the end.

The original Library of Congress caption is enclosed within quotation marks; any editorial emendations are within brackets. Occasionally, *"sic"* has been noted in the original captions to alert casual readers that the text is not the editor's. Sometimes additional materials (captions from other FSA photographs of the same scene or different captions and further information from later FSA collections) are also noted or quoted.

The Written Texts: The selections from the New Mexico Federal Writers' Project/Program files are either complete manuscripts or excerpts from longer documents. Deletions from the original typescripts are indicated with ellipses, as are places where the excerpts are preceded and/or followed by more text in the original. Editorial emendations appear within brackets.

The verbal sketches are treated as "photographs," each with a new title supplied by the editor. The end captions suggest those of the FSA photographs: collector's name, original title of manuscript, place and date. Full bibliographical notes on each of the twenty-five written sources follow the portfolio of plates and texts.

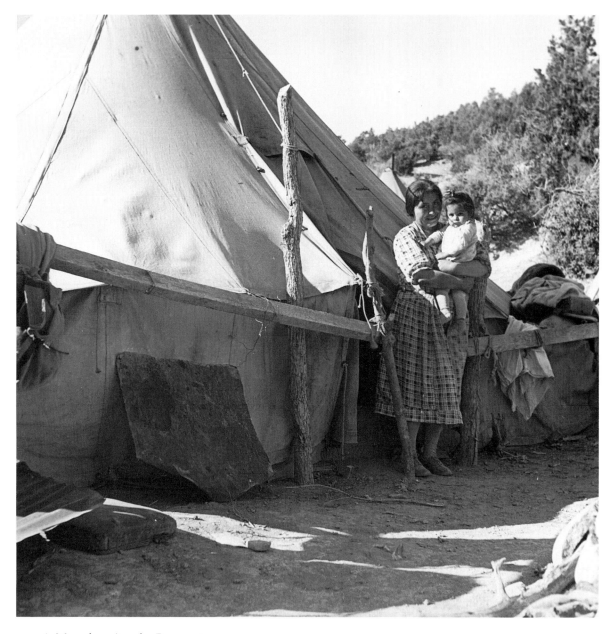

1. Mescalero Apache Reservation,
April 1936. "An Indian woman
in front of her tepee. Many Indians
live in such primitive [*sic*] tents."
Arthur Rothstein. LC-USF 34-1910-E.

HOME

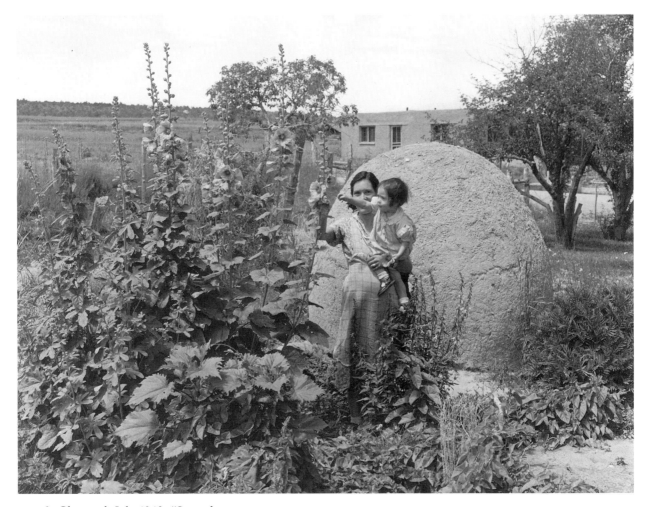

2. Chamisal, July 1940. "Spanish-
American woman and baby in a
flower garden," with *horno*, or
outdoor adobe oven, behind.
Russell Lee. LC-USF 34-36998-D.

3. Questa vicinity, September
1939. "Front yard of a Spanish-
American farm home." Russell Lee.
LC-USF 34-34242-D.

E A R L Y R A N C H H O M E S

. . . THE EARLY RANCHER's first home was his camp or chuck wagon. By way of example, Cowden Brothers [W. H. (Bill), George, John M. and Buck] and their young wives (as did many others) lived in cow camps for several years. In the beginning their homes were the wagons in which they had come to the country [in 1885], the wives cooking on camp fires beside them. An extra wagon sheet afforded additional roof space. Tables for dining were not to be expected. But the wagon tongue with a corn case stuck under had considerable seating capacity for guests.

If one were settled it saved steps—climbing ones—to set the wagon box, cover and all, from the running gear onto the ground. This was the general storehouse and best bedroom. (Other camp beds were unrolled anywhere.) Thus divided, the wagon provided not only a home, but the running gear was still a conveyance, and now light enough to be easily usable.

A *dugout* on the north side of a draw (which is the south slope) was warmer in winter even when the roof was a wagon sheet or a few buffalo hides. But if one could afford to haul in boards or poles sufficient to support a dirt roof, then luxury was approximated.

Many of the *first one-room camp houses or "choseys"* were of limestone rock common to much of this section. They were thick walled—two feet perhaps— often a crude construction of rocks of all shapes and sizes put together without benefit of mortar of any sort. But they were surprisingly warm.

In the more *permanent rock houses* the rock was put together with mud, and often years later "pointed" on the outside with cement mortar. Many of this type are still in use. To be able to afford the few feet of lumber for window and door facings and roof meant a new home, an acquisition which some prairie wives dreamed of for years before possessing.

. . . The *early rancher's indifference to his abode* may be better understood when it is recalled that he felt more at home outdoors than in any sort of house. A house to him was but a necessary commissary and storage room, and shelter in time of storm. [1973 edited version: "Not so with his wife. Always she wanted a better house, a more comfortable house, with more of the beautiful things that women cherish to make their house-bound days more pleasant."]

Note: Cowden Bros. and their wives, it may be added, lived not only to own but to thoroughly make use of and enjoy palatial homes in Midland, Fort Worth, and San Antonio (Tex), where they sometimes referred to their cow-camp days as the happiest they had known. This must be largely attributed to their youth; but was it not in some measure due to their simple yet adventurous living there?

May Price Mosley. From "Customs and Conditions of Early-Day Ranch Life." Lea County, November 1936. [1]

4. Pie Town, May 1940. "A community settled by about 200 migrant Texas and Oklahoma farmers who have filed homestead claims. Home of Jack Whinery. The original dugout house cost him 30¢ for nails and took him ten days to build. Since then two small sleeping rooms have been added. The fence was built by Mrs. Whinery after her husband had cut the slats." Russell Lee. LC-USF 34-36534-D.

5. Mills, May 1935. Caption in
Wood (1989:36): "Wife and child
who are clients for resettlement."
Dorothea Lange.
LC-USF 34-1629-E.

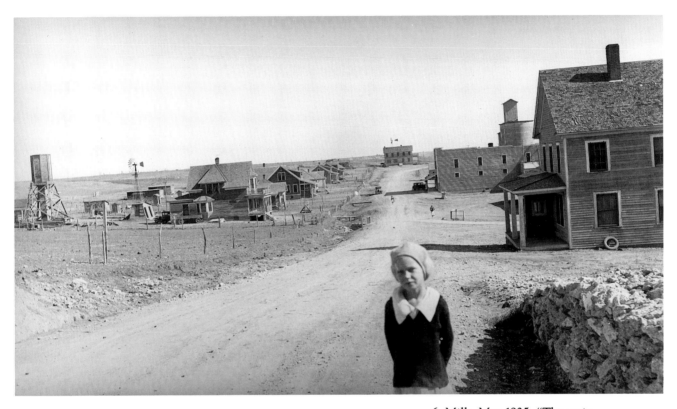

6. Mills, May 1935. "The grain elevator in the background at the right has been abandoned long ago. The bank is also closed." (Caption in Wood [1989:38]: ". . . Because of a high rate of foreclosures, the bank had failed the year before. The Wilson Company store and hotel, right, closed in 1940.") Dorothea Lange. LC-USF 34-1627-E.

A D O B E P L A S T E R I N G

THE CHATTERING and laughter of the women could be heard coming from the east side of the house. This was a sign that they were nearly through with their task for in the morning they had started plastering the west side to avoid the sun, which could still direct its rays with some force this late in September. Swinging around the house in direct opposition to the sun's rays, they had succeeded in keeping in some measure in the shadows cast by the walls.

However, neither the heat nor the hard labor seemed to bother these four women as they labored at a task which in this community was acknowledged as one for women only. Men, if tolerated at all, were allowed only to mix the dirt and straw into mud of the required consistency. Even then, one of the women would work and knead small batches at a time, carefully extracting stones and other objects and leaving the mud a smooth paste. When expertly applied by her coworkers, this left an outer covering fully protecting the house from the elements for many seasons.

Nearing the end of their task seemed to add more zest and spirit to their joking and gossiping. Passersby were cheerfully answered as they joked with them in passing: "¿ *Ya acaban las golondrinas con su nido?*" ("Are the swallows nearly through with their nest?") This allusion referred to the barn-swallow, which expertly fashions its nest while clinging to a wall. Also there was a hint of the constant twittering that the swallows indulge in while so employed

Lorin W. Brown. From "Jesu' Cristo a Caballo." Córdova, November 1937. [2]

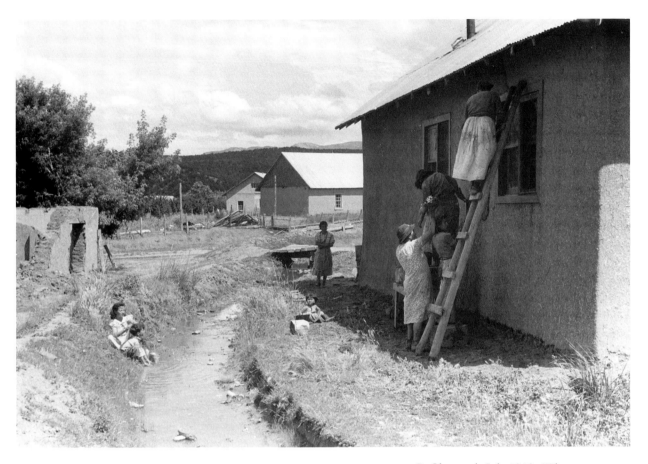

7. Chamisal, July 1940. "Plastering
adobe house and washing near a
irrigation ditch." Russell Lee.
LC-USF 33-12810-M4.

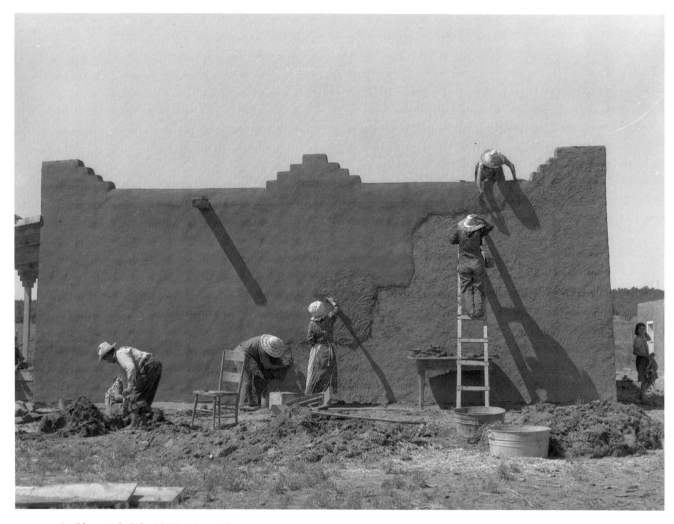

8. Chamisal, July 1940. "Spanish-
American women replastering
an adobe house. This is done
once a year." Russell Lee.
LC-USF 34-37082.

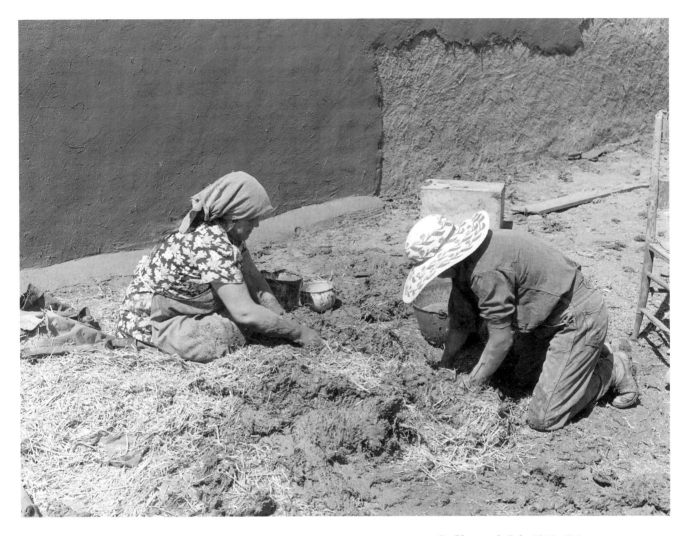

9. Chamisal, July 1940. "Mixing
straw with mud to make the plaster
which is used to re-plaster the
houses each year." Russell Lee.
LC-USF 34-37051.

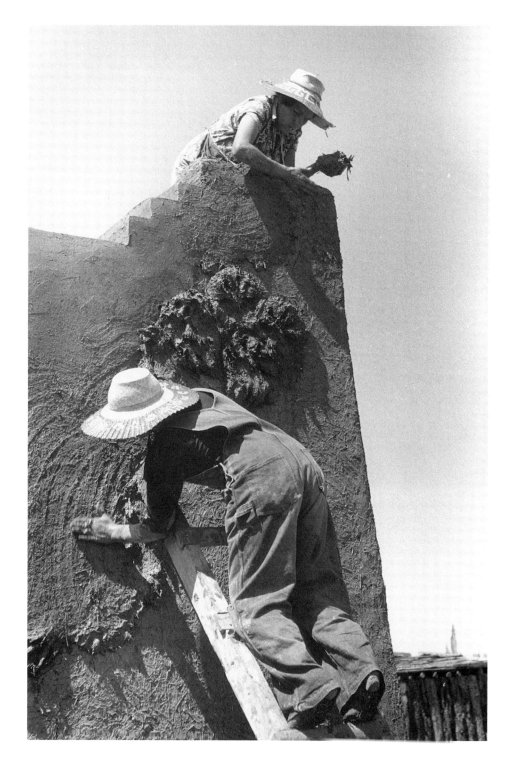

10. Chamisal, July 1940.
"Spanish-American
women plastering an
adobe house."
Russell Lee.
LC-USF 33-12823-M3.

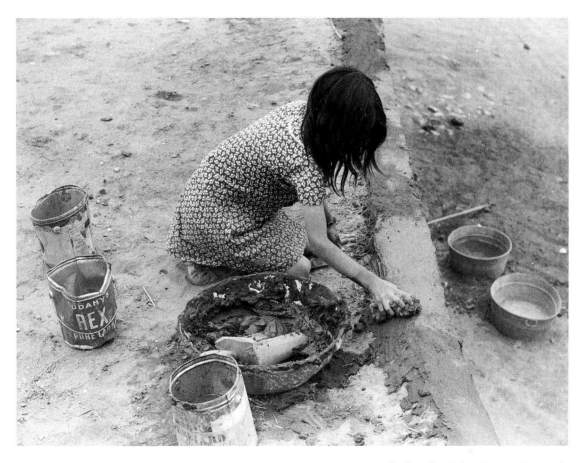

11. Costilla, July 1940. "The rough
adobe plaster is smoothed with raw
wool and water." The girl is kneeling
on the flat, earth-covered roof of
the house. Russell Lee.
LC-USF 33-12832-M2.

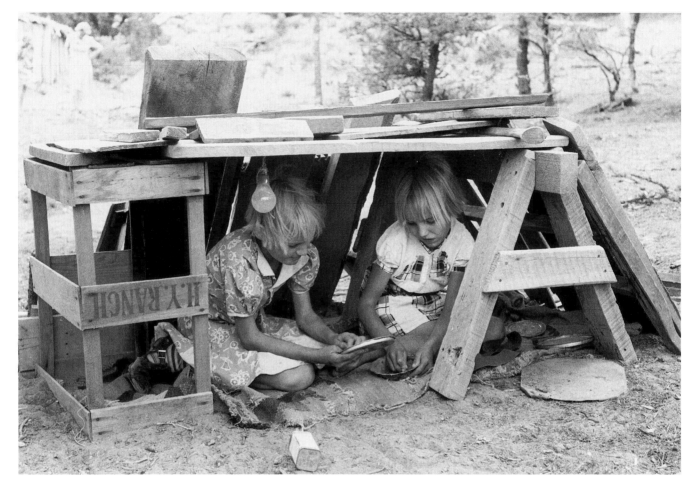

12. Pie Town, June 1940. Caption
in Wood (1989:5): "The [Jack]
Whinery children make do with
sawhorses and crates as they play
house in their backyard."
Russell Lee. LC-USF 33-12744-M4.

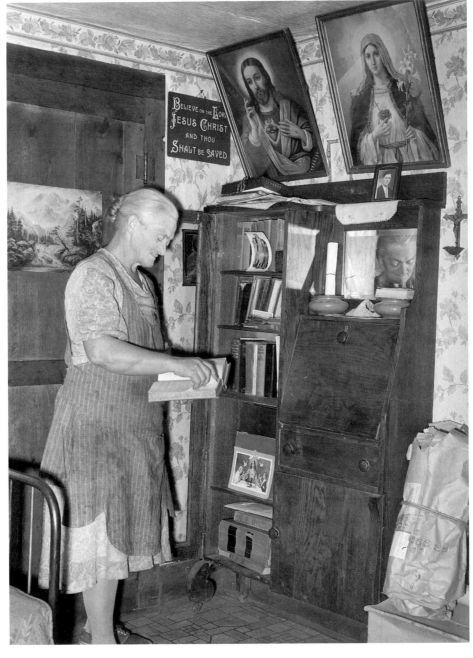

13. Pie Town, June 1940. "Mrs. George
Hutton [Sr.], homesteader [from Oklahoma
in 1931], in front of her bookcase." (Caption
in Wood [1989:75]: "A deeply religious
woman, Mrs. Hutton reads her Bible daily
and attends church every Sunday.")
Russell Lee. LC-USF 34-36760-D.

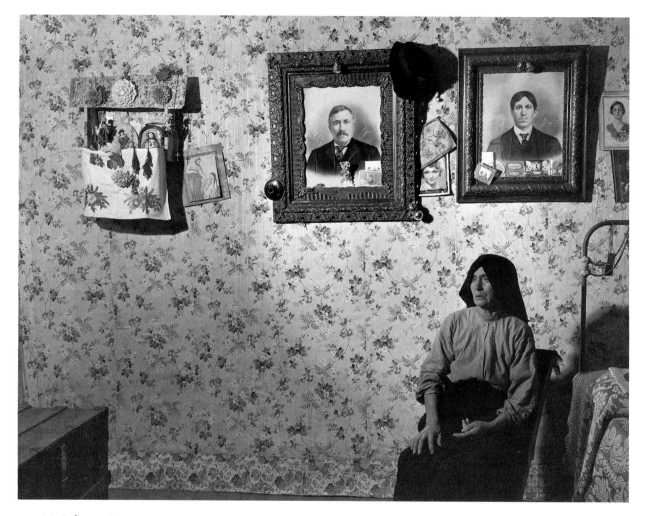

14. Peñasco, January 1943. "Home
of an old couple," elsewhere iden-
tified as "Spanish-American couple
in an isolated section" (LC-USW
3-13687-C). John Collier, Jr.
LC-USW 3-13688-C.

L I V I N G A L O N E

CATALINA WAS ALL of eighty years old, very small and thin with white hair and brown eyes that sparkled when she talked, such a contrast to her little brown wrinkled face. She had on a black dress, blue apron, and a gray cloth tied over her head. She lives alone in her two-room adobe house, which was part of the big house her father and mother had owned.

Her father's name was Antonio Viareal and her mother's María Vigil. They had four children, two boys and two girls. All were born in the same little village of Alcalde.

Catalina was the youngest of the children. Her brothers died when small. When her sister became a young lady, maybe fourteen years old, she married and with her husband moved to Taos. So that left Catalina alone with her parents. Yes, she could have married if she had wanted to. Ever so many men had asked for her. But no, she would not leave her mother and father alone.

She stayed single and took care of them, and when they died they left her the house and land. From then on she lived by herself, planting her garden in chili, onions, *calabazas* and melons. The rest of the land she gave out on *partido* (shares), one part for her and three parts for the one who planted it. Of course, the planter furnished everything and did all the work, and when the crop was ripe he gave her her share.

No, she was not afraid to live alone. She knew everyone in the placita and was related to most all of them. A little girl stayed with her at night. Her sister had tried for years before she died to get her to sell her house and land and to go and live with her. But no, she did not want to give up all her father and mother had left her. Why, her land was the best in the placita.

Her father had bought it from an Indian when he was married, paying the Indian two *sarapes* (Navajo blankets) and a *fanega* of wheat. (A *fanega* is twelve *almudes*. An *almud* is a wooden box twelve inches square and six inches high. The *almud* was used for measuring grain.) Then he built a room and later on added four more rooms. There used to be *dispensas* (store rooms) and corrals, but they fell down years ago, as did three of the rooms. The remaining two were still good and warm. No, she did not like stoves but had a small one in the kitchen to cook on. In her room she used her fireplace. Heat from stoves gave her headaches.

Catalina's house was more or less like all the other houses in the village with white-washed walls and corner fireplace and the *vigas* (beams or logs) on the roof almost black with age. Her room was small but clean and cool. In the corner stood an old spool bedstead piled high with freshly washed bedding. On the floor was a *jerga* (carpet) woven from natural colored wool in black and white checks. Against the wall were two or three chairs with gay

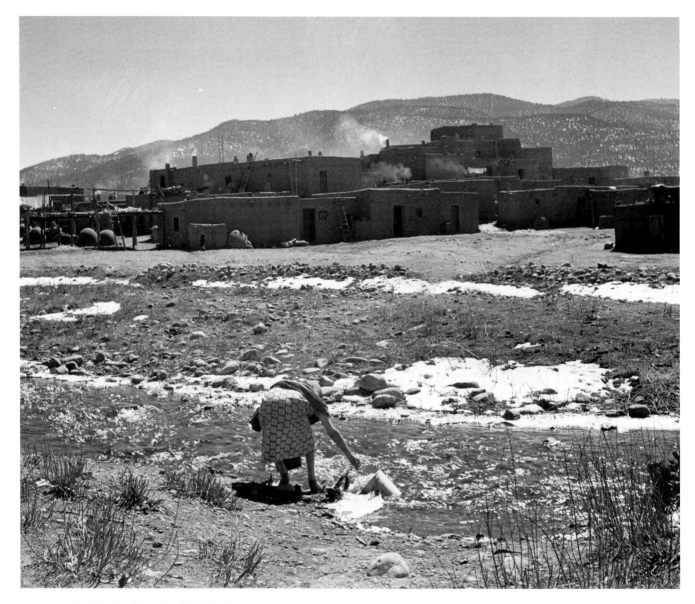

16. Taos Pueblo, April 1936. "Indian woman fetching water from the Rio de Taos which runs through the village."
Arthur Rothstein.
LC USF 34-2957-E.

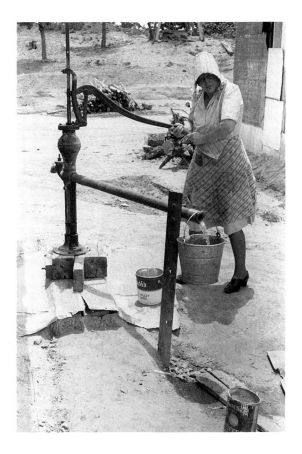

17. Pie Town, June 1940. "Pumping water." In LC-USF 33-12743-M5, a man drawing water from this pump is identified as a "homesteader pumping water from a well owned by Harmon Craig. Few farmers can afford their own wells in this arid area where water is in short supply—and expensive" (Wood 1989:53). Russell Lee. LC-USF 33-12756-M5.

18. Pie Town, June 1940. "Mrs. Bill Stagg drawing water from her well which is in the enclosed porch of her log house." Russell Lee. LC-USF 34-36667-D.

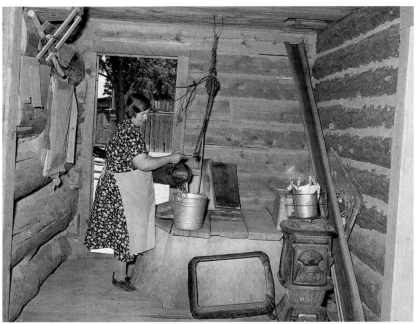

W A S H I N G A N D S O A P M A K I N G

MARCELINA, OR LINA as she is called, was born and raised in Pojoaque. Her parents died when she was a baby. She was raised by an Aunt whose name was Josefa Vigil.

Lina's husband's name was Tiofilo Garcia; he died last year. She has five children, three boys and two girls; also many grandchildren. All her children are married. One daughter, who is a widow lives at home with her.

Lina's husband left everything to her: a large piece of land, with a small orchard on it, a good four-room house, three cows, two horses, and a pig. She does not know how many acres there are, but has the deeds which say how much land there is.

Tiofilo did not leave their children anything, because they were still young, and could work as he and Lina had, and buy land for themselves. Had he left them a share now, they would sell it and buy automobiles, and Lina would be left without a home. Anyway when she died, they would get it all, and she wouldn't be here to see them quarrel over it.

Lina is sixty-eight years old, of medium height, and quite fleshly. She and her daughter do most of the work. She gave out some land on shares, the rest she looked after. She raised wheat, beans, and corn, besides drying a lot of fruit. She has enough food to last her a year.

Now Lina is all through with the *Misa de cabo de año* ("Mass on first anniversary of a death") for Tiofilo. This Misa is a very important event to country people and is looked forward to like a wedding or feast day.

Tiofilo died a year ago, on the ninth of November, and ever since Lina has been preparing for this Misa.

First she went to see the Padre, who told her he would have to say the Mass on the sixth, because that was the only day he could spare. Lina thought it was too bad, but then that was only three days earlier, and after all it did not make much difference. She had one of her grand-daughters write to the sons and daughters who lived away to be there on the sixth instead of the ninth. She also invited all her relatives and friends.

Then she began to get ready. First the bedding had to be all washed in *amole*. *Amole* grows on the mesas. There are two kinds, *palmia ancha* and *palmia angosta* ("wide and narrow leaf"). The wide leaf is considered the best for washing, it makes the best lather.

The roots are the only part used. They are dug up and placed in the sun to dry. When needed [they] are pounded on a stone until shredded, then placed in a tub with a little water to soak for about fifteen minutes. Then the roots are stirred around and around, until the tub is filled with suds. The roots are then taken out, and hot water added. In this blankets and clothing

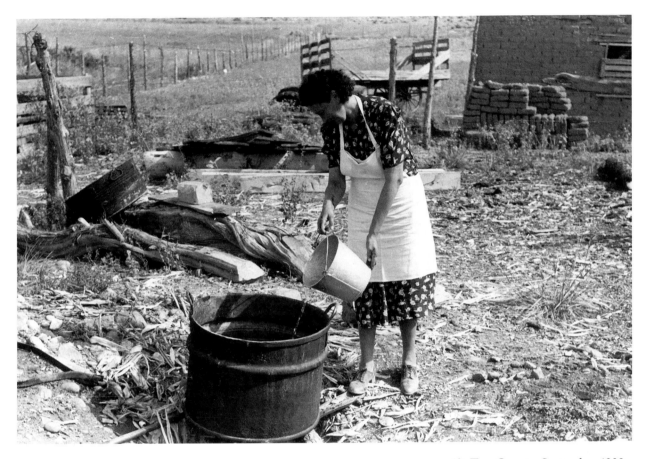

19. Taos County, September 1939.
"Spanish-American Farm security
administration client adding water
to soap in the kettle." Russell Lee.
LC-USF 33-12407-M5.

are washed. And the walls inside the house are white-washed with yeso,
and the patios swept. Then she and two other women went and cleaned
the church, and draped it all in black, and wound black ribbon around
two dozen wax candles she had brought. This was done because
everything had to be in mourning.

 Lina sold some of her wheat and two cows. These cows were in the
hills, and might be stolen this winter, so she thought it best to sell them,
and get the money for the Misa.

Annette H. Thorp, "Lina." Pojoaque, December 1940. [4]

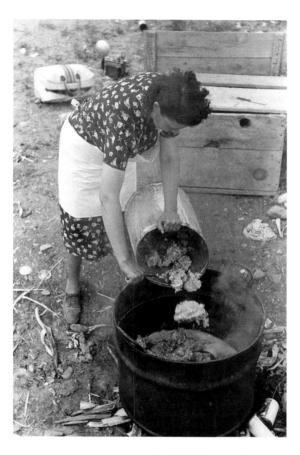

20. Taos County, September 1939. "Spanish-American Farm security administration client emptying a pail of grease into a kettle for the purpose of making soap." Russell Lee. LC-USF 33-12406-M1.

21. Taos County, September 1939. "Spanish-American Farm security administration client stirring a kettle of soap." Russell Lee. LC-USF 33-12405-M1.

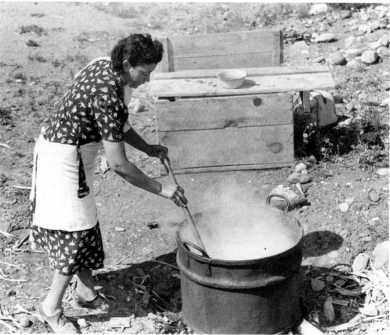

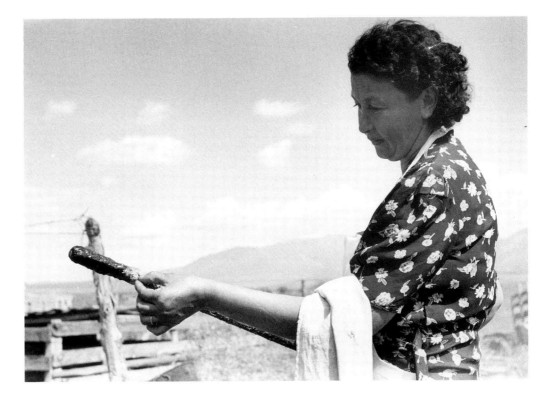

22. Taos County, September 1939. "Spanish-American Farm security administration client testing soap on the end of a stirring stick to see if it has cooked enough." Russell Lee. LC-USF 33-12426-M1.

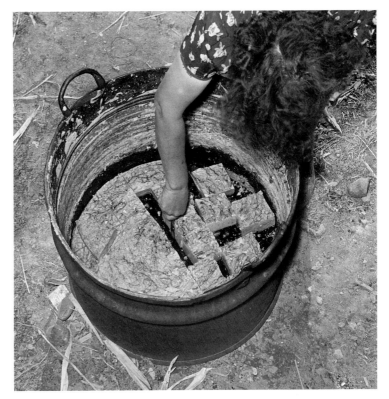

23. Taos vicinity, September 1939. "Spanish-American woman cutting soap which she has made in this kettle." Russell Lee. LC-USF 34-34276-D.

C O O P E R A T I V E L A B O R

THE YEAR 1900 seems to have been an imaginary dividing line between the old and the new, in Taos County. Many of the old customs seem to have gone with the turn of the century. The modern supplanted the ancient with a suddenness, almost imperceptible at that time, but now clearly perceived by those casting a retrospective glance to that date—1900 A.D.

The modern inventions, that have revolutionized modes of travel, farming, etc., have, also, effected changes in the relationship of people towards one another. In no other respect has this change been more marked than in the lack of neighborly cooperation among the present-day inhabitants of the very same villages, where the people of that former era worked together at their daily tasks. Now, money is the primary consideration in all matters where the employment of labor is concerned. In those times, neighbor helped neighbor, without a money consideration between them. This spirit of cooperation developed from the times of the first settlers, when it became essential, almost imperative, for the preservation of their very existence, against the hostile tribes of Indians that inhabited the region.

This cooperation custom was strikingly demonstrated during the harvest season, when as many as twenty men gathered, each with his sickle, at the field of a neighbor, to help him reap his wheat, oats, or other similar grain

Other work in which they cooperated was the cleaning, carding (combing) and spinning of wool, the plastering of their houses, the washing, at the river, of their blankets and mattresses (twice a year—in the spring and in the fall), when the spread of colored blankets formed a curious display on the fences of the village. These jobs were done by the women. The making of syrup from corn-stalks was also a cooperation job, done by the men and the women, working together. This was always an interesting event, to both adults and children

Reyes N. Martínez. From "Cooperation." Taos County,
February 1937. [5]

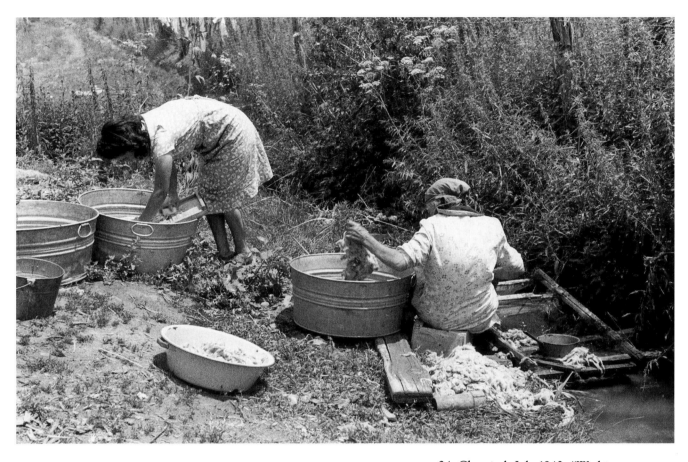

24. Chamisal, July 1940. "Washing along the irrigation ditch." The older woman on the right is identified as Gomasínda Martínez, "washing wool in the irrigation ditch" (Wroth 1989:72). Russell Lee. LC-USF 33-12815-M3.

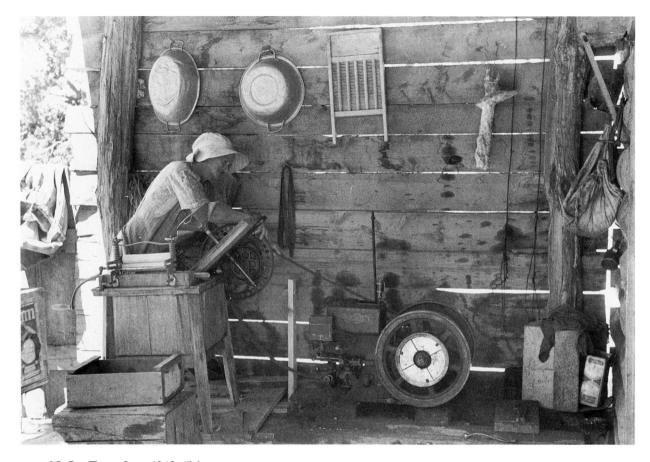

25. Pie Town, June 1940. "Mrs.
[George] Hutton [Sr.] opening an
electric washing machine. Her son
[George Jr.] put in all the electric
equipment." LC-USF 34-36537-D
shows "George Hutton Jr., working
on his homemade electric plant."
Russell Lee. LC-USF 33-12727-M1.

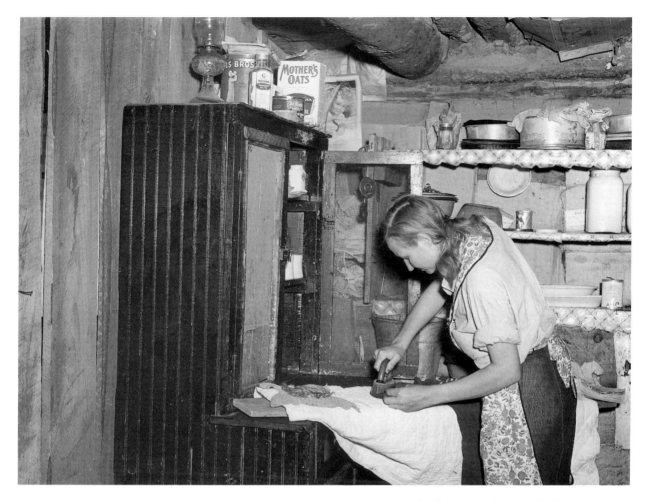

26. Pie Town, June 1940. "Mrs. Faro [Doris] Caudill ironing. She was born and finished high school at Sweetwater, Texas before coming with her husband to homestead." Russell Lee. LC-USF 34-36581-D.

FOOD

AND

COOKING

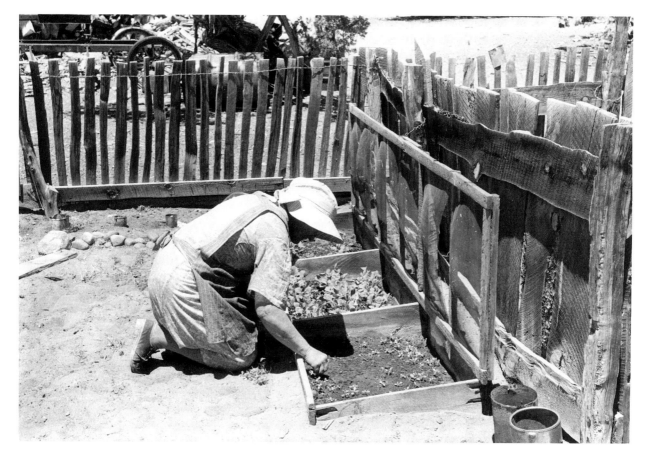

27. Pie Town, June 1940. "Mrs.
[George] Hutton [Sr.] working in
her seed bed." Russell Lee.
LC-USF 33-12728-M2.

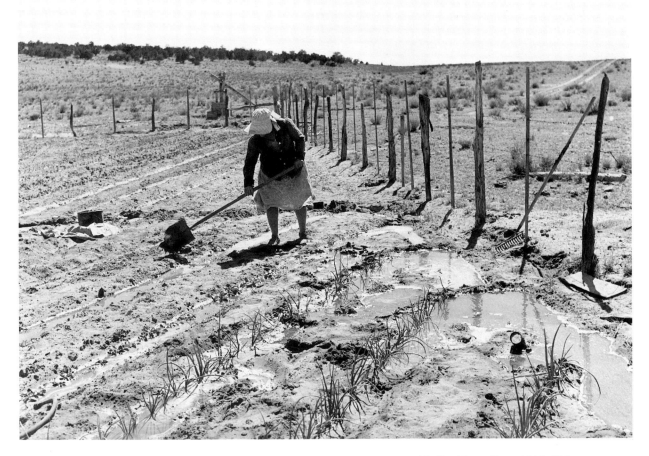

28. Pie Town, June 1940. "Mrs. George Hutton [Sr.] irrigating her garden. The Huttons have ample water at their farm. This was the only irrigated garden seen in the section." Russell Lee.
LC-USF 34-36755-D.

PLASTERING, COOKING
AND PLANTING

WOMEN THINK THEY work now days. *Pero no*, they don't know what work is. The Americanos have made it so easy for them now. They would die if they had to work like she did when she was young, and strong, said Chana, a very old woman who lives in the country with her granddaughter.

Cresenciana, as she was named, does not know in what year she was born. She looks close to ninety, is small, thin and has very little hair, and what there is of it, is white. Her skin is light brown. Si, she was *muy blanca y bonita* ("white and pretty") when she was a girl. She cannot see well any more, and has to walk with a cane. She wears dark calicos for every day, but on Sundays her black dress, which she likes the best.

She can't do much any more, but sits on the shady side of the house, and watches that *los niños* ("the babies") don't fall in the *acequia* ("ditch"), or the chickens get into the garden. But when she was young, and had her own home, how she could work.

She had four sisters and one brother, they are all dead now. Her Mother and Father, whose names were Antonia Valencia and Policarpio Montoya, were born, and lived in the same place, as she does now [Santa Cruz, at El Sombrio or El Santo Niño].

No she does not know how to read or write, there was no need for an education in those days. They never got letters, and if they did, there was an *escrivano*, who read and wrote their letters for them. Oh yes he charged, twenty-five cents for writing a letter, but nothing for reading it for them.

She was *muy joven* ("very young") when she married Manuel Atencio. He was a good man. His Father gave them a piece of land, and they built two rooms. Manuel layed the adobes in the walls, and put on the roof, then turned the house over to her. She mixed her own mud *con muncha paja* ("with straw"), and plastered the walls so smooth, and then white-washed them with *yeso* ("gypsum"). Oh no, the men did not do the plastering or white-washing, that was women's work. Men could not do it as nice as the women did.

She cooked in a fire-place, the food tasted so good cooked that way, much better than on a stove. She had a *tinamaiste* ("iron ring with three legs") to put her pots on. Not like the pots they have now days. But *ollitas de barro* ("clay pots"). She rubbed them inside and out with grease, and put them on hot coals to burn. That kept them from leaking. There are no beans, like the ones cooked in *ollitas de barro*. Her *tortillas de maiz* she cooked on a *comal* ("flat stone, or iron like a griddle pan"). She also built an *orno* ("oven") outside to bake in. Oh what good bread *de arina de trigo* ("wheat flour") she used to bake. And in the fall roasted green chili in it, peeled and hung it up to dry for winter use.

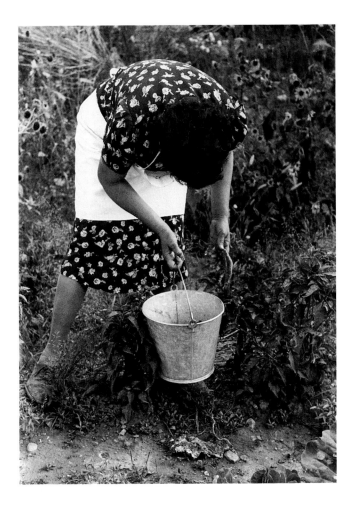

29. Taos County, September 1939. "Spanish-American Farm security administration client picking chili *[sic]* peppers in her garden." Russell Lee. LC-USF 33-12425-M4.

She planted much chili, melons, onions, and garlic to put in the chili. Yes and *punche* ("native tobacco"). No you can not get punche any more. She always raised a lot, and knew how to cure it too. Chana picked the leaves off, and piled them in a corner, put a blanket over it, and when the leaves were yellow, put them in the sun to dry. Then it was ready to smoke, with *ojas de maíz* ("corn husks"). And you never got *tos* ("cough") like you do now smoking Americano tobacco and paper.

Chana had many children, but raised only four, a boy and three girls. While they were still small Manuel died. After that she did all the work, besides raising her family. She taught her children to respect *los mayores* ("the old"). When she was young, children were taught to be very respectful and to obey their elders. If you asked for a *jumate* ("dipper") of water, and if there was a child present, he or she jumped right up, ran to bring you a drink, and stood with their arms folded until you had finished. *Pero ahora*, if you ask for a drink, they push it towards you and run. No, there is no *crianza* now days

Annette H. Thorp. From "Chana" Santa Cruz, October 1940. [6]

30. Taos vicinity, September 1939.
"Spanish-American woman placing
and turning peppers on the stove."
Russell Lee. LC-USF 34-34226-D.

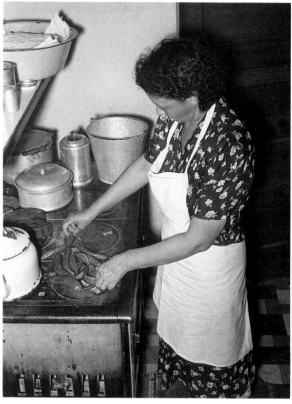

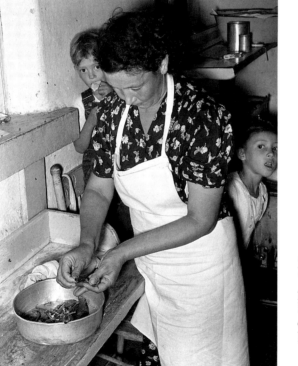

31. Taos vicinity, September 1939.
"Spanish-American woman peeling
peppers after the skins have been
loosened by heating them on top
of the stove." Russell Lee.
LC-USF 34-34217-D.

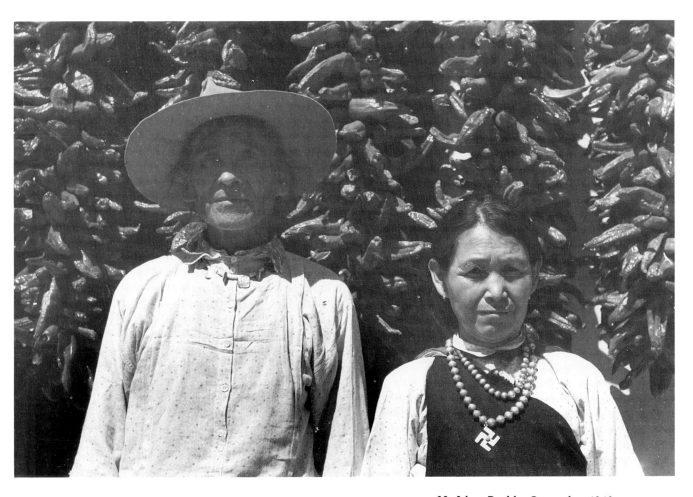

32. Isleta Pueblo, September 1940. "Indian and his wife in front of a house on which chili [*sic*] peppers are hanging." Russell Lee. LC-USF 33-12931-M2.

THE CARROLL GOAT DAIRY

WE DO NOT PRESENT this goat dairy exactly as a work of art, but it is at least rather an unusual feature. It is located on the south side of Cherry Street about midway of the block east of Third Street in Clayton. Here we find the family of Lawton Carroll, who is the owner of the goats, although the work of the dairy is done by the two children—Billie aged eleven years and Freda aged twelve years.

They have six milch goats and three young ones. During the past two or three years that the dairy has operated they have served from three to seven customers at a time, selling up to six or seven quarts per day. Most of it is sold for the use of invalids or undernourished children. Billie states that the six goats, which are fed ordinary cow feed and not tin cans as generally reported, are kept for just about the same cost as the upkeep of one cow and that the Carroll Dairy has one goat that gives her two and a half quarts per day.

Genevieve Chapin. From "Unusual Industries." Clayton, July 1936. [7]

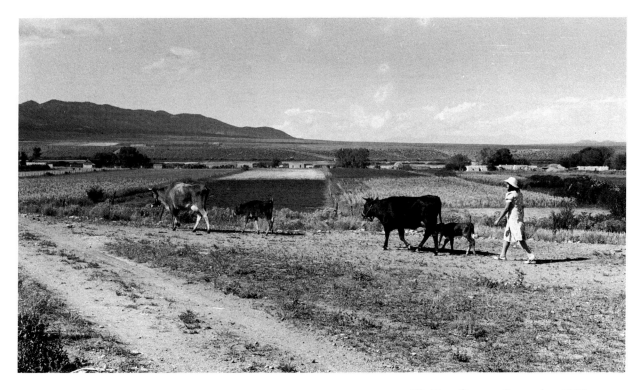

33. Taos County, September 1939.
"Daughter of a Spanish-American
Farm security administration
client driving cows to pasture."
Russell Lee. LC-USF 33-12408-M2.

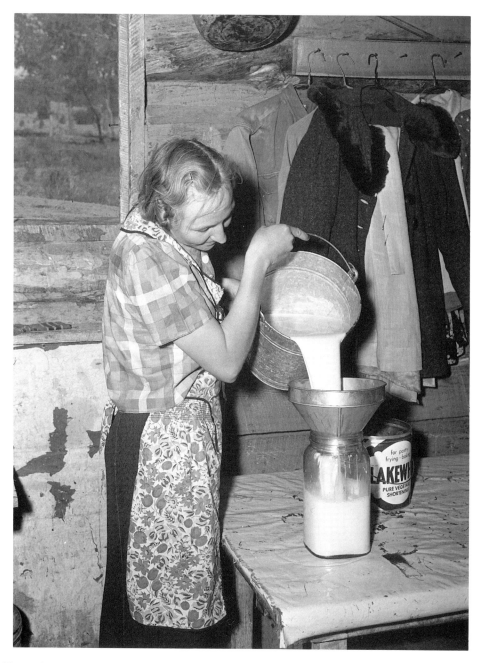

34. Pie Town, June 1940.
"Mrs. Faro [Doris] Caudill straining
milk. Every farmer has milk cows
for his own use and sells cream to
the creamery at Socorro."
Russell Lee. LC-USF 34-36550-D.

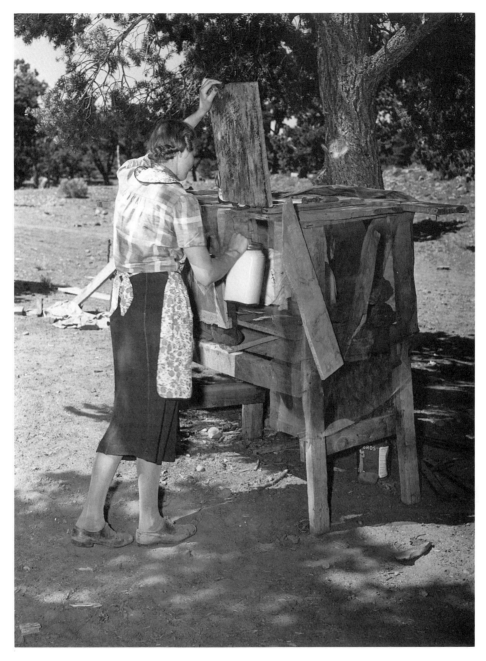

35. Pie Town, June 1940.
"Mrs. Faro [Doris] Caudill placing milk into homemade cooling box. Damp cloths are wrapped around buckets and jars of milk, and rapid evaporation in the open-air produces sufficient cooling to keep milk." Russell Lee.
LC-USF 34-36529-D.

E A R L Y R A N C H D I E T

. . . WITH COWS ALL around them the *earliest ranchers seldom had a drop of milk.* This was especially true in bachelor or line camps. Getting away from camp by daylight or shortly thereafter was an especial pride of the good cowhand, and getting in after dark was a habit. He had neither the time nor the inclination to milk a cow. Though he roped, branded or drove cows all day long, he just drank his coffee straight and liked it. Range cows were generally very poor milkers. But wherever a woman and children came to live men tied wild cows up to snubbing posts till they had tested and tamed one or two into milk cows. And spoke of breaking a cow to milk much as they would a *bronc* to ride.

With milk and butter—even in small quantity—*the woman on the ranch,* wife of the owner or ranch-keeper, was able to vary and add to the regular menu. If she had inviegled her husband into letting her bring out a half dozen hens, eggs now and then afforded further variations. And though they might regard milk as strictly a baby food, cowboys responded appreciatively to cakes, pies, and butter for hot bread. Some ranch housewives became especially adept at making dried apple jelly, dried apple and vinegar cobblers, or fried pies— from dried peaches; but the prize for variety goes to the women who baked tall layer cakes with a different sort of dried fruit between each layer.

One *odd fact regarding the ranch diet* was that in later years when a few vegetables were grown by women, who hungered for them and who regarded them as the greatest treat one could imagine, few of the men cared enough for the green vegetables to eat them, nor cared for the cornbread served with them. Both were greatly enjoyed by the women.

Beans, *frijoles,* were not so generally a staple among the early ranchers as they have become since. Beef was still cheap and much preferred

May Price Mosley. From "Customs and Conditions of Early Ranch Life." Lea County, November 1936. [8]

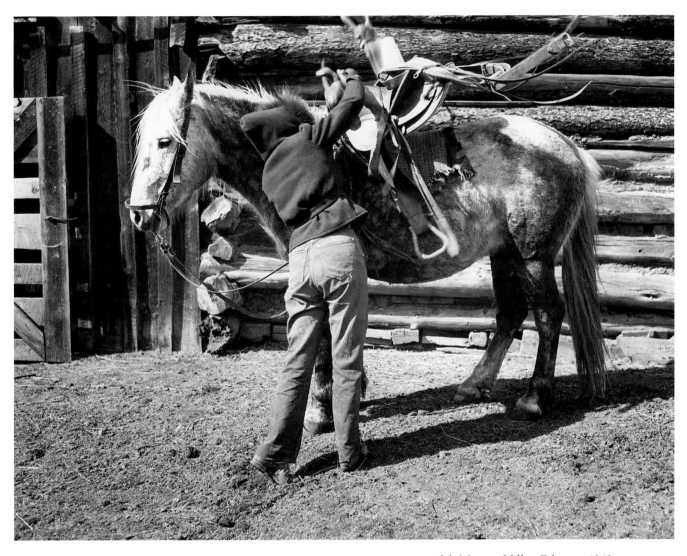

36. Moreno Valley, February 1943.
"[Oldest] daughter of George Mutz,
a second generation cattleman, of
Moreno valley, 'saddling up' to
drive stock." John Collier, Jr.
LC-USW 3-18632-C.

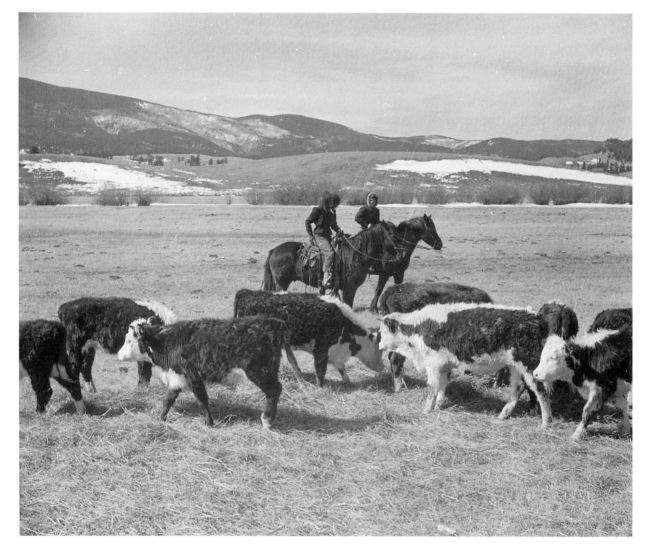

37. Moreno Valley, February 1943.
"George Mutz' [oldest] daughter
holding cattle on the winter range
for feeding." John Collier, Jr.
LC-USW 3-18862-E.

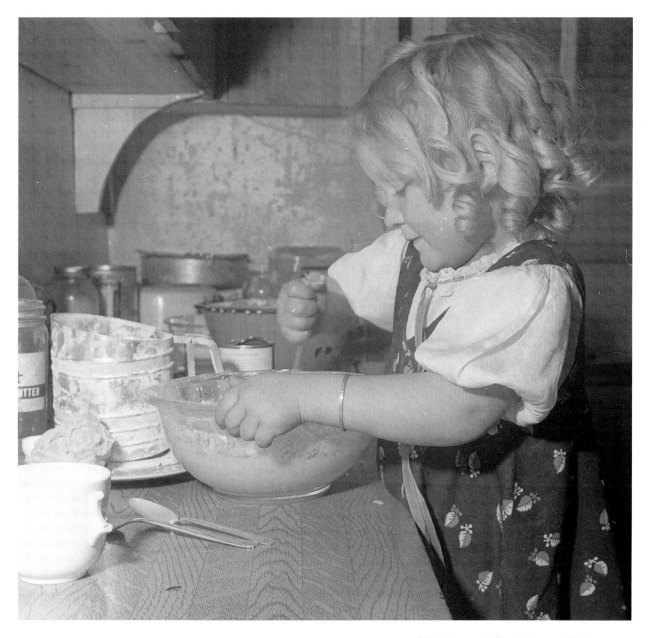

38. Moreno Valley, February 1943.
"George Mutz' youngest daughter
helping with the cooking." John
Collier, Jr. LC-USW 3-18873-E.

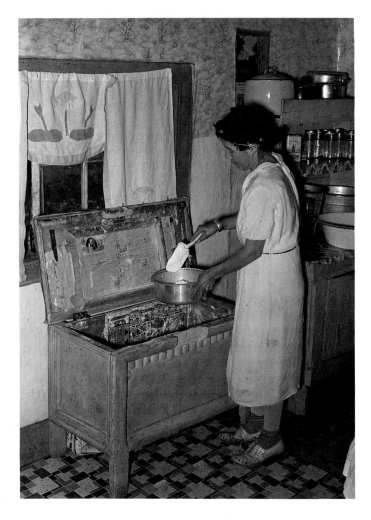

39. Taos vicinity, September 1939. "Spanish-American woman taking flour from old type flour bin in her home." Russell Lee. LC-USF 34-34233-D.

40. Taos vicinity, September 1939. "Spanish-American woman covering dough so that shaped loaves will rise evenly." Russell Lee. LC-USF 34-34235-D.

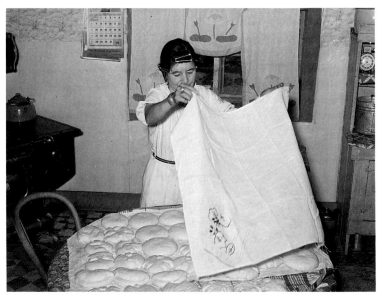

B A K I N G

... TWO DAYS BEFORE the Misa, bread, *empanaditas* ("small turn-over pies") and *panocha* were baked in the outdoor oven. These ovens resemble bee hives, having a small door on one side, and a hole at the top. A fire is built inside, and when thought hot enough, the fire is raked out, and tested by holding a small piece of wool on a wooden paddle inside of the oven. If the wool should scorch a dark brown, the oven is too hot. Then a piece of sacking or cloth is dipped in water, and the inside swabbed, and tested again. When the wool comes out a light brown, then the oven is right. The bread is placed inside, and the door and chimney sealed up with mud. The bread is left in the oven for about an hour, telling the time by looking at the position of the sun. This is baking on a large scale, and is only done for wedding and feast days.

Panocha.—This is a pudding made of wheat sprouted in a dark place, after which it is ground into flour. This is mixed in boiling water like making mush, then put in an *olla* or pot, and placed in the oven, and left to bake, for a day and a night, or twenty-four hours. It comes out an amber color, is very sweet, and considered a great luxury

Annette H. Thorp. From "Lina." Pojoaque, January 1941. [9]

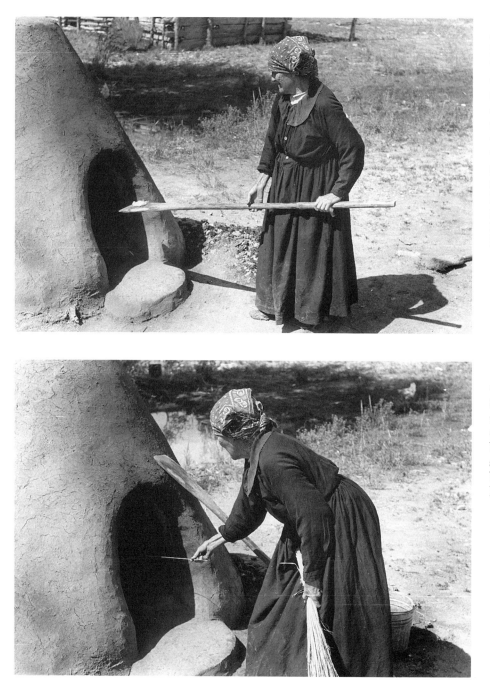

41. Taos vicinity, September 1939. "Spanish-American woman testing temperature of earthen oven by determining length of time required to scorch wool." This seventy-five-year-old grandmother was not actually baking; she simulated the process so Lee could photograph it (Wroth 1985:133). Russell Lee. LC-USF 33-12421-M2.

42. Taos vicinity, September 1939. "Determining temperature of earthen oven in which bread will be baked by seeing how fast straw burns." Russell Lee. LC-USF 33-12421-M3.

43. Taos vicinity, September 1939. "Pulling out hot coals with wet cloth." Russell Lee. LC-USF 33-12422-M4.

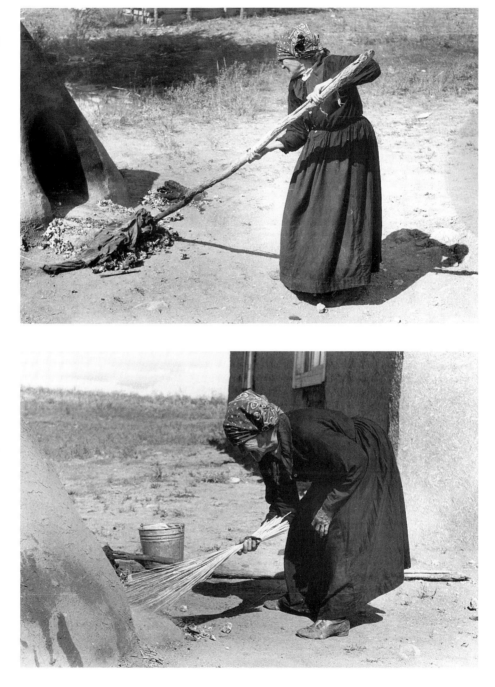

44. Taos vicinity, September 1939. "Sweeping hot coals from outdoor earthen oven after it has been heated to proper temperature to bake bread." Russell Lee. LC-USF 33-12421-M5.

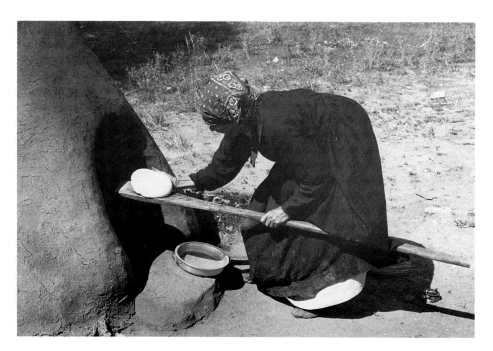

45. Taos vicinity,
September 1939.
"Spanish-American
woman putting load of
bread into oven."
Russell Lee.
LC-USF 33-12420-M2.

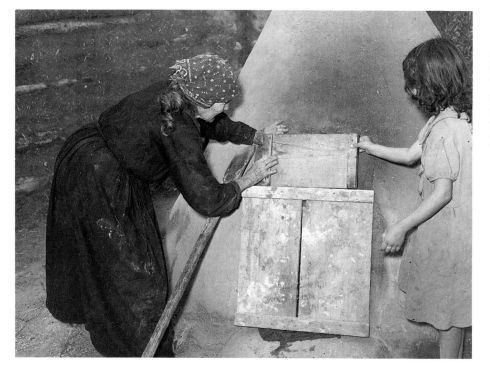

46. Taos vicinity,
September 1939.
"Covering entrance of
outdoor earthen oven
while bread is baking."
Russell Lee.
LC-USF 34-34316-D.

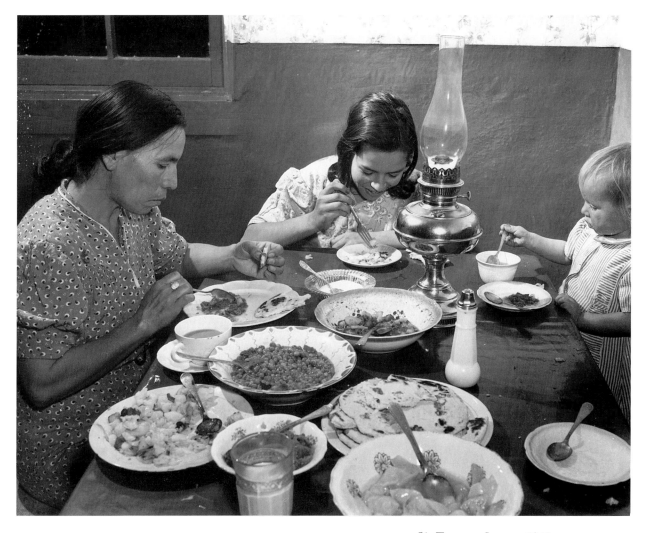

51. Trampas, January 1943.
"Supper time at the home of Juan
[Antonio] Lopez, the majordomo
(mayor)." Pictured (l. to r.) are
Maclovia Lopez and her daughters
Manuelita and Luissa. John
Collier, Jr. LC-USW 3-15235-C.

EDUCATION

AND

WELFARE

TIA LUPE, VILLAGE
WISE OLD WOMAN

ONE OF THE MOST beloved characters in Córdova was known to young and old as Tía (Aunt) Lupe. Guadalupe Martínez was her formal name, but she was aunt to the entire village, a great-hearted, simple, understanding soul to whom all turned for advice or consolation. Her vast store of wisdom and knowledge, gained through a long life rich in experience, was for anyone who needed it, and she dispensed it with humor, grace, and tolerance. It was her skillful blending of these, whether for spiritual or physical need, that made her the counsellor, guide, and the healer of the community.

When she was long past seventy, her small, slender frame was still erect and her bearing was that of authority derived from inner integrity. Her small, finely shaped hands were gnarled by many years of washing wheat in ice-cold water, working in the fields, sewing, spinning—all the countless tasks in which those hands had been busy, whether in her own home duties or helping neighbors garner their harvest or keep their homes in order when they were unable to do so. Her fine features, straight nose, and generous mouth above a firm chin gave evidence, even when full of wrinkles, that she had been a beauty. Her light complexion proved her a *rubia*, as redhaired women are called. But it was in her clear, sparkling brown eyes that she was known for what she was, so alive they were, so full of the zest and joy of life, always alight with interest and ready to show concern on hearing of someone's distress, the light leaping higher when hearing of another's good fortune. She was a picture of neatness, from her center-parted hair, brushed back and gathered in a smooth knot, to her small feet encased in soft black shoes. And her voice! That was as full of light as her eyes, and her laugh was a joy to hear because of its infectious quality. She was all things to all people. She had a youthful quality and an understanding of the young that drew them in groups to her door; a recalcitrant child changed into an obedient and loving one under her care. She knew all ages and sympathized with them, and her breadth of understanding seemed to encompass all situations and all phenomena

Throughout her life in Córdova, Tía Lupe earned the gratitude of the whole village by her willingness to help in any time of distress. She was the first to offer aid to an overburdened mother or to the ailing and infirm, and so it was not strange that during the last years of her life she never lacked for food or wood. There was always some loving neighbor who would leave a load of neatly split wood on her doorstep at night so that when she awoke it would be the

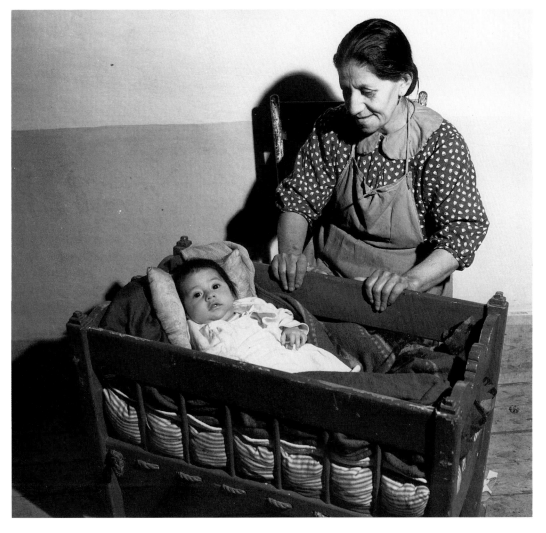

52. Trampas, January 1943.
"Spanish-American mother and
her baby." Identified as Onofre
Leyba Vigil, "who lived to be
ninety-eight years old" (Wood
1989:96). John Collier, Jr.
LC-USW 3-17890-C.

first thing she saw. If she knew or suspected the identity of the donor, she
would hasten to his or her home to help at whatever tasks needed doing. Her
friends wanted her to rest for the few years left to her long life, but she would
and did pay or try to pay for everything she received, and her rich store of
anecdotes and sprightly conversation would have made her welcome whether
she turned a hand at helping or not

Lorin W. Brown. From "Tía Lupe." Córdova, n.d. [11]

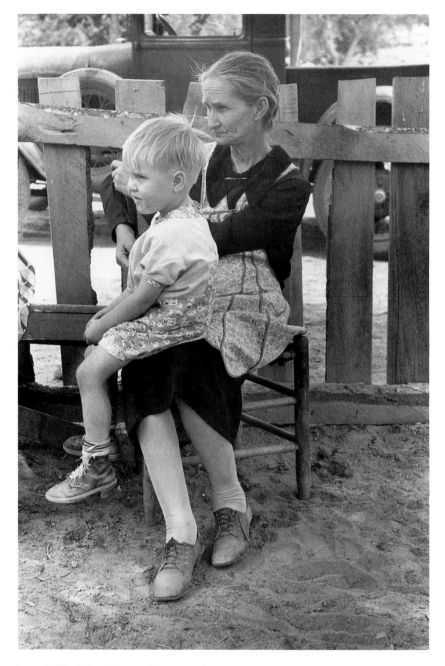

53. Pie Town, June 1940. "Mrs. Besson, homesteader
from [near Frederick,] Oklahoma, with her grand-
son." The photograph is part of a series: "Group of
farmers, homesteaders, and their families visiting all
day Sunday to celebrate a birthday"(LC-USF
33-12736-M3, in Weigle and White 1988:367). In
another series, Mr. and Mrs. Besson are photograph-
ed "eating cake and coffee at a forty-two [domino]
party at their home" (LC-USF 34-36578-D, in
Weigle 1985:75). Russell Lee. LC-USF 33-12754-M1.

SCHOOLING AND PLAY
ON EARLY RANCHES

. . . THE EARLY RANCHER usually moved his family to town, for a few years at least, when his children reached—a rather late—school age. Other ranch children learned the rudiments of reading, writing, and arithmetic about their mother's knee, and were later sent away to school. Governesses were employed in some instances (until cowboys married them).

One of the *first attempts at having a school* on the plains was made in the 1890's when Miss Annie Adcock taught the Medlin, Causey, and Dunnaway children in a bedroom of the Jerry Dunnaway ranch home. Though the ranch child's educational advantages were so exceptionally meagre, if at all attracted to learning, he often brought an interest so fresh and eager that his advancement was speedy.

The Prairie Child had little but leisure. In emulating his elders he played all day perhaps at breaking *broncs*, roping, riding. Rocks, horns, wild gourds all became cattle that must be branded, penned, etc.; wells must be dug. The little girls were almost always tomboys—and out in the open too; though they of course found time for innumerable dolls, often homemade, and for dishes. *Children were so few* in the ranch country that they were invariably teased and indulged by the cowboys; neither of which improved their dispositions, but seemingly increased their spunk.

Isolation and *loneliness of ranch life seems never to have bothered children*, since they knew nothing else. Lacking playmates and toys, and having so much time on their hands, they were especially addicted to pets. Pet horses, cows, *burros*, dogs, antelope, rabbits, coyotes, lobo wolves, cats, prairie dogs, chickens, and birds served as playmates and playthings. Perhaps from his association with these the prairie child could not help being a little wild. When taken to town or thrown with crowds he was usually beside himself in excited play, or else suffered from a pathetic timidity equalling torture.

From his environment of the range he took self-reliance and resourcefulness, and was robust. And though he possessed a marked ability at getting along alone, he often lacked the faculty of getting along with others—at least to the extent of fitting into the pattern of the modern business and social world. The freedom and leisure of early ranch life had a strong tendency to make one almost incurably individualistic—to resent and suffer from long hours of regular indoor employment almost as the Indian suffered from such confinement.

May Price Mosley. From "Customs and Conditions of Early Ranch Life (Lea County)." Lea County, December 1936. [12]

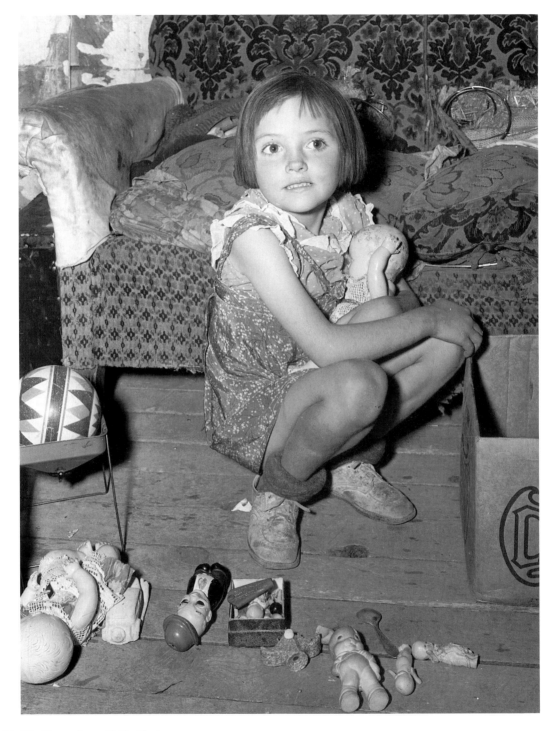

54. Pie Town, June 1940. "Josie
Caudill with her toys." Russell Lee.
LC-USF 34-36561-D.

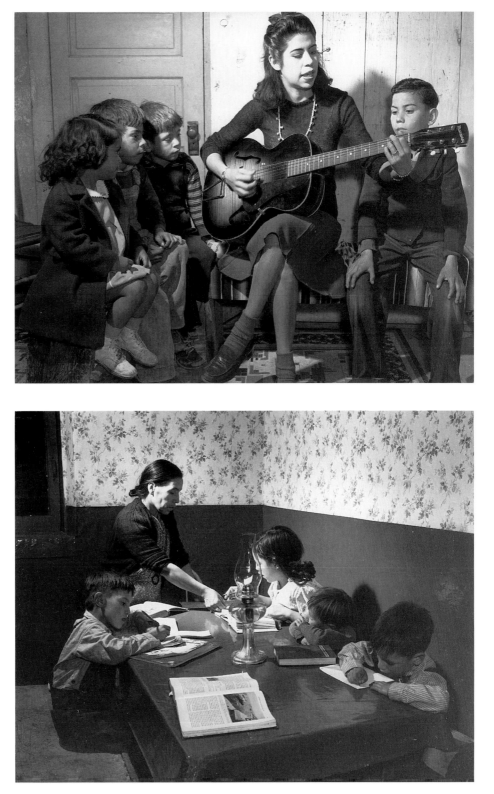

55. Albuquerque, February 1943. "Spanish-American girl *[sic]* singing folk songs to her little brothers and sisters." John Collier, Jr. LC-USW 3-19196-C.

56. Trampas, January 1943. "Mrs. Maclovia Lopez, can read and write English well; she also keeps the family books in the evenings and helps the children [daughter Manuelita; sons Pat, Liberato and Victor not clearly identifiable here] with their homework." Maclovia Lopez died in 1967. "Despite the fact that his wife briefly taught school in Las Trampas, Juan [Antonio] Lopez did not believe in education for his family. Only three of the Lopez children were allowed to finish high school; no matter how hard she tried, Maclovia was unable to persuade her husband to change his mind about the rest of them. 'A woman can never go against her husband,' [daughter] Bertha [Lopez Vigil] says. 'It's not our way. The man's word was always final, and she had to accept it even when she knew he was wrong' " (Wood 1989:113-14). John Collier, Jr. LC-USW 3-15202-C.

MRS. LENA KEMPF MAXWELL,
PLAINS SCHOOLTEACHER

MRS. LENA KEMPF MAXWELL was born in Adamsville, Logan County, Kentucky, in 1874. She came with her father C. J. Kempf in 1908 to New Mexico and took up land according to the fourteen-month plan at that time. They could take up only 160 acres. They filed four miles north of Grady, New Mexico, west of State Highway Number Eighteen.

"Yes, I have had sorrow and privations mixed with the pleasant things that come to the life of a pioneer. I had been a bride, a mother and a widow all within the space of one year. I came with my father, C. J. Kempf, and settled near Grady in 1908.

"I had been prepared for a teacher and had taught four years when we came to New Mexico. I was a high school graduate, had training in the teacher normals in Kentucky and attended Bethel Female College and held a sixteen year's state certificate from Kentucky, but I had to begin again to prepare for teaching in New Mexico, for nothing but work from accredited colleges from other states will be recognized in this state. I entered the college at Las Vegas and continued my work until I acquired a college degree and thereby a lifetime certificate. I have taught sixteen years in New Mexico and have been principal of some of the best rural schools in New Mexico and incidentally in the United States. The equipment for these schools was purchased by money made from pie suppers, tackey parties and festivals common in this state. There were also some private donations.

"Yes, we have had 'hard times'—cold weather, hot weather, storms, snows, and fires and other inconveniences common to people on the frontier. There have been years when people were compelled to use a great deal of ingenuity to be able to stick to their claims

"I think that it was in 1910 that we had a very severe snow storm. It was necessary for my father to send some money to the bank. He saw a man who was going to Clovis from Grady so he gave the money to him. That night after he had given the money to the man he heard of some of his dishonest dealings, so he awoke me about twelve o'clock and told me to get a horse from the stable and lead him to my brother-in-law's about three quarters of a mile and tell my brother-in-law to go to Grady and get the money and take it himself. The snow had been on the ground for seven weeks and the reason I had to lead the horse was because the ice was so slippery that my father was afraid for me to ride. I had to go across the pasture and open the gates. I was nearly frozen when I arrived. I awakened the family and my brother-in-law set out for Grady at once. My sister begged me to stay until morning, but I knew that my father would be uneasy, so after resting a half hour and drinking some coffee

I started home. Just outside the yard gate I heard the wolves, but I went on. I found a stick and waved them back, but they came to within fifteen feet of me. I waved the stick and flung my bonnet around my head several times and hallooed at them. I was at the pasture gate and I thought that they would get me, but as I went through I yelled at them and threw the stick and ran with all my might to the house. The wolves were famished for they could find nothing to eat in the two or three feet of snow. They had eaten several young calves and colts in the pastures and human flesh would taste just as good to them. They attacked some school children at San Jon, a small school not far away, but the older children fought them off.

"During the same time my sister and I climbed a snow bank fifteen feet high to reach a feed stack on the other side. At one end of the stack the snow was not very deep. We would tie a rope around the bundle of feed and draw it up. I would hold the feed and she would climb a little farther up.

"During the snow storm a ferocious jersey bull that was chained in a pen was covered up in about five feet of snow except just a breathing hole. We had to dig down and get the chain and turn him loose. We shoveled the snow from around him and by the time we got him out of the snow some of the fight was taken out of him. Stock suffered a great deal that year and several times we have had some severe snows. I taught school several miles from home and often I have had to shovel two or three feet of snow out of the schoolroom before I could even get a fire built

> *Belle Kilgore. From "Mrs. Lena Kempf Maxwell, School Teacher & Museum Manager, Clovis, New Mexico." Clovis, June 1937.* [13]

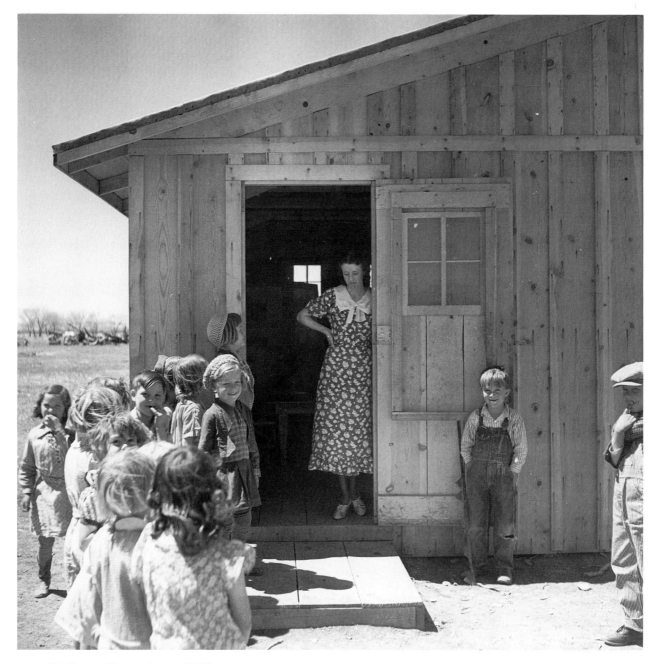

57. Bosque Farms, August 1936.
Caption in Wood (1989:47): "A
teacher and students at the
temporary school, hastily erected
when rehabilitation clients poured
in." Arthur Rothstein.
LC-USF 34-2974-E.

58. Questa, February 1943.
"The first grade."
John Collier, Jr.
LC-USW 3-18767-C.

59. Pie Town, June 1940.
"Youngsters Sunday
school class at the Farm
bureau building." Another
view of this interior, with
the "school children's
band" in performance,
LC-USF 34-36684-D, is in
Wood (1989:59). Russell
Lee. LC-USF 34-36704-D.

D O Ñ A J U A N I T A ,
V I L L A G E H E A L E R

EVERYBODY IN TAOS knows Doña Juanita [Montoya de Martinez, Brown's grand-mother]; she has become an institution through many years' practice of her profession. She is what is known as a *médica* or healer, versed in the knowledge of massage treatments, bone-setting, and familiar with the large assortment of native herbs and the efficacy of each in the treatment of different ailments. A great faith is attached by the native people to the benefits of massage treatments, and this is Doña Juanita's long suit, her unusually large frame and strong capable hands being admirably suited to this type of healing. So it is that at one time or another she has been in every home in Taos County, or its individual members have been in her home for treatment of minor ailments. ailments.

With her talent for healing, which is mixed with a slice of shrewd native psychology, she has a great gift of narrative, so that her visits to a home are looked forward to because of the fund of anecdotes and gossip which she always brings with her

Lorin W. Brown. From "The Black Dog." Taos, July 1937. [14]

EARLY RANCH LIFE DOCTORING

. . . WHEN ILLNESS OR ACCIDENT befell, much was endured without a doctor's aid or an anesthetic. Hours of racking pain by the patient, days of haunting apprehension and worry by his companions (whether family or friends), doing everything known or possible for them to do to aid him. Caring for the sick was a much lonelier vigil here than in rural sections not so thinly settled; unless some one was sent for help much sickness and death might come without one's neighbors knowing of it. Eyes anxiously bright, features tense with anxiety, but brave with smiles—and a prayerful hush over all—marked many such crises, with maybe a tear brushed quickly aside as one worked.

On rare occasions *the lone cowboy in a bachelor camp* has suffered, even deliriously, the fever and pain of pneumonia or a broken limb, without aid from any person—no doctor, no medicine, no nurse, little food, and perhaps no fuel in winter—and survived. Found perhaps by some passer-by in his convalescence.

On ranches where there were only men, *about all the medicine around was axle grease and coal oil*—and strychnine for coyotes. But most every ranch woman had a medicine box full of *home remedies* which she administered almost to the extent of "practicing medicine." A few had doctor books. One [Mrs. E. H. Price] who could never stand sewing wounds always kept a supply of court plaster on hand; and did some very effective patchwork with strips of it. Another first-aid soul [Mrs. Emma Causey] kept a kit of all sorts of homeopathic or similar remedies.

Some cowboys were surprisingly *adept nurses*. Others in an emergency have set broken limbs, pulled joints back into place, and performed crude but effective bits of surgery such as completing the amputation of a finger with a pocket-knife [Millard Eidson], sewing a lip in place with a common needle and thread [Billy Oden] (all victims were without an anesthetic), and the cleansing of a woman's gunshot wound with a willow withe and white silk (from the sleeve of her wedding dress) [Boston Witt].

When the rancher developed pneumonia, a cowboy's horse fell with him, breaking his leg or crushing him internally, when a mother sickened, or a child met accident, *the quickest*—and about the only—*way to medical aid* was by wagon, or hack, and team the hundred or hundred and fifty miles to town, with the patient on some sort of bed in the back of the vehicle. A runner on horseback was sent ahead to arrange for fresh relay teams at ranches along the way, and changed horses there himself. He sometimes brought a doctor out to meet the entourage.

Such trips were rarely undertaken save in *life-and-death cases*; and the decision of whether the patient should best be subjected to such a trip was ever a grave and difficult one to make. One seldom knew which would be the greater risk: the lack of a doctor's care or the long hard trip. Ofttimes the patient was out of danger and on the road to recovery by the time he reached a doctor. Some never lived to see him, but died as the hack or wagon creaked and jolted along the way, attended only by a kindly but helpless comrade or two.

May Price Mosley. From "Customs and Conditions of Early Ranch Life (cont'd)." Lea County, December 1936. [15]

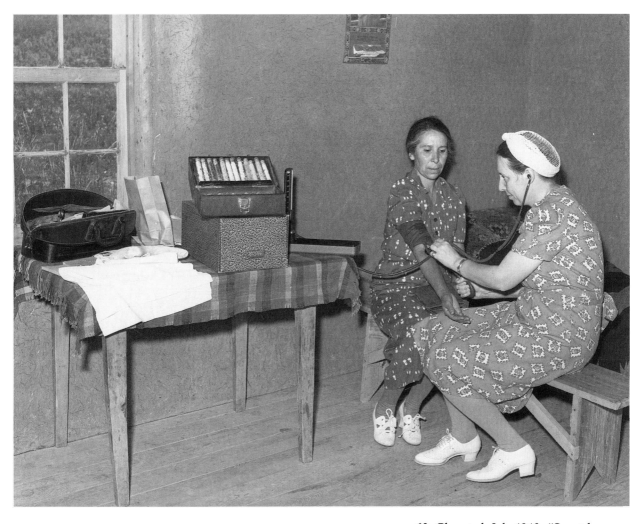

60. Chamisal, July 1940. "Spanish-American woman being examined in the travelling clinic which comes from the Presbyterian Hospital in Embudo." Identified as Felicita Frésquez de Domínguez (Wroth 1985:103). Russell Lee. LC-USF 34-37143.

K N I T T I N G

COMING DOWN THE HILLS that flank the village of Arroyo Hondo on the south side, Tía Toña Trujillo, believed by many to have been an old witch, on account of her disheveled appearance and the strange stories told about her, drove her burro homeward, well loaded with wood, along the well beaten path over which she was wont to travel almost daily. Sometimes the load of wood would shift to one side, causing the burro to crane its neck sidewise, in an effort to counterbalance its weight against that of the load of wood and avoid falling over and rolling down the hillside. The old woman had a passion for knitting woolen socks and she always carried to the hills with her, her ball of yarn, set of knitting needles and any socks unfinished from the previous night, knitting as she went along. This would divert her attention from the donkey, so that, at times, she was unconscious of the shifting of the load of wood, until the poor burro stopped and gawked at her pitiably, whereupon, she would lay down her knitting and untie the load of wood, allowing it to drop to the ground. She would then rearrange the wood on the burro's back, tying it tightly with the rawhide thong she used for the purpose.

A load of wood is arranged on a burro's back in *"tercios"* (Spanish—thirds), that is, three bundles. A bundle is placed on each side and a third bundle is placed between and over them on top. The side bundles must be as nearly equal in weight as possible. The third bundle is larger and is spread over the other two, making a well-rounded load. The rawhide thong is placed about the bundles and passed under the belly of the burro in such a manner that only one knot is made to secure the load, so that, when unloading, by untying the one knot, the tercios fall apart and down the sides of the donkey. It requires some skill to adjust a load of wood on a burro's back, and the patience and stamina that only a burro possesses, to carry it.

Emerging from the sloping pathway into the roadway, the lady knitter would climb and sit on top of the load of wood and ride, knitting diligently all the while, into the village to her home at the lower end of the east alley of the village, where the burro occupied one of the rooms of the house, as its quarters. The sight of the old woman, perched on her lofty position, like a chicken on a roost, excited the curiosity of the children, who flocked to the roadside

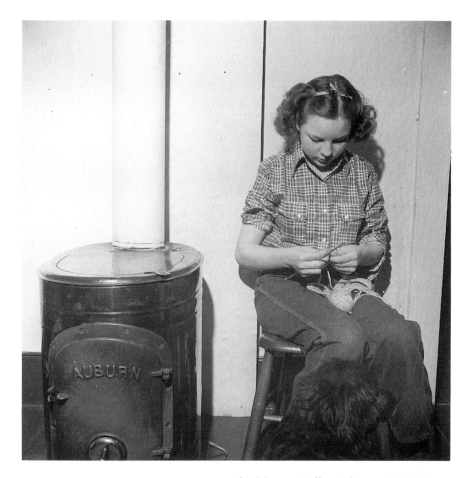

64. Moreno Valley, February 1943. "A
rancher's daughter knitting during a
poker party at George Turner's ranch."
John Collier, Jr. LC-USW 3-18992-E.

to watch her pass by. Sometimes the ball of yarn would slip from under her
arm, where she was wont to carry it, and drop to the ground, unnoticed by
her, completely unwinding itself, the long yarn trailing along the ground,
behind the burro, for several yards; and the children would pick up the end
of it and follow in a noisy group till Tía Toña happened to notice them,
whereupon she would pull up the yarn and rewind it into a ball, while the
children laughed at her and dispersed.

Tia Toña made her living by selling her wood at twenty-five cents per load,
and the socks that she knitted, at fifty cents a pair. She died about the year
1896.

*Reyes N. Martínez. "The Knitter and the Burro." Arroyo Hondo,
March 1937.* [16]

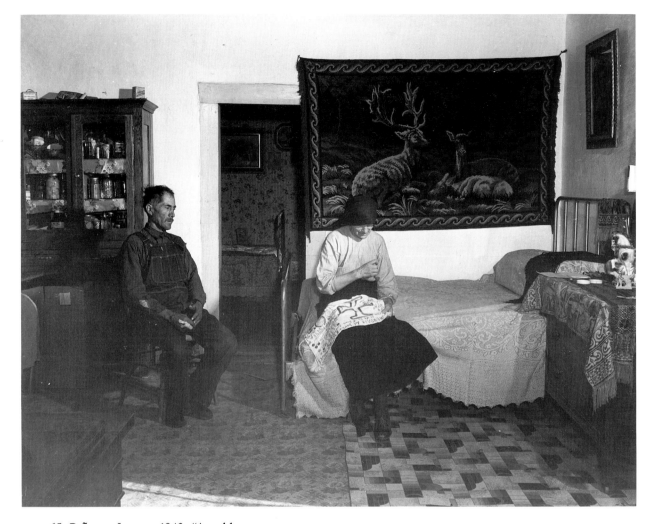

65. Peñasco, January 1943. "An old
couple who live near the town."
John Collier, Jr.
LC-USW 3-13762-C.

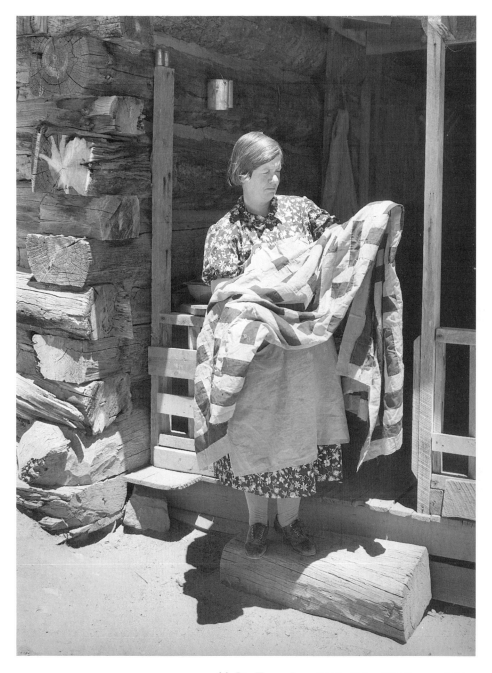

66. Pie Town, June 1940. "Mrs. Bill Stagg exhibiting a quilt made from tobacco sacks which she ripped up, dyed and pieced. Nothing is wasted on these homesteading farms." LC-USF 34-36692-D shows "Mrs. Bill Stagg with state quilt which she made. Mrs. Stagg helps her husband in the fields with plowing, planting, weeding corn and harvesting beans. She quilts while she rests during the noon hour" (Wood 1989:68). Russell Lee. LC-USF 34-36691-D.

N E E D L E W O R K

WORKING IN STILL different fabric we find another artist in the person of Mrs. Fannie Potter who lives two doors east of First on the south side of Walnut Street in Clayton. Mrs. Potter, who is a native of Old Mexico, specializes in fine Spanish needlework and has worked at her chosen art since early childhood. She received most of her training from her mother, later perfecting her work during five years spent in the Convent School at Aguas Calientes in Old Mexico. Now she, in turn, is passing on her skill to her young daughter Susie, who works with her and acts as her interpreter.

The skillful fingers of these two Spanish women have many beautiful works of art to their credit—mostly in Mexican drawn work, Italian cut work and embroidery. One can scarcely realize the infinite patience and exactitude that has directed these women in the setting of these beautiful, painstaking stitches.

Besides the pieces she has made for herself, Mrs. Potter has given private lessons for some fifteen years. During the past three years she has had a W.P.A. teaching project for needlework in Clayton. During this teaching work numerous films for educational purposes have been made of her work. She sells to many out of state points and has donated several valuable pieces to different churches.

Genevieve Chapin. From "Unusual Industries." Clayton, July 1936. [17]

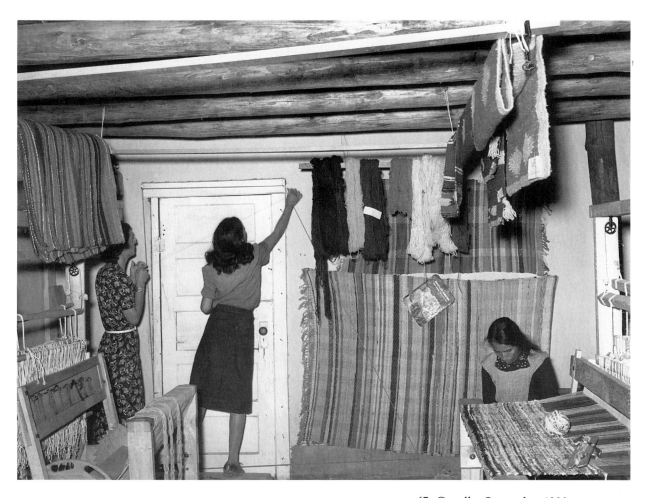

67. Costilla, September 1939.
"Interior of the WPA weaving
project shop." A community voca-
tional school sponsored by the
State Department of Vocational
Education had been set up by
March 1936 and may have formed
the basis for this WPA project
(Wroth 1983:29; 1985a).
Russell Lee. LC-USF 34-34264-D.

COMMERCE

S O P H I E H A N S E N , P R O S P E C T O R

WHEN KINGSTON, NEW MEXICO, was a booming mining town in the Black Range, one of the most interesting residents there was Miss Sophie Hansen, Swedish owner of the Occidental Hotel. A short time ago, at the age of 81, she was living alone with her chickens, with which she shared her humble shack, when a terrible winter blizzard struck Kingston.

At one time in the good old days, Miss Hansen owned a large herd of cattle for which she was offered $12,000.00 during the World War, but she refused the offer and later lost them all during a terrible drought. She remained very active in her old age, energetic and optimistic, doing her own assessment work on her mining claim, a few miles west of Kingston, and joining in with other oldtimers who always believed that Kingston would stage a comeback. At the age of 81 she walked eight miles to Hillsboro, the county seat, to make proof of labor on her claim, and returned the same day on foot.

Sophie Hansen is a true example of a real pioneer New Mexican who had many hardships to endure and difficulties to overcome but who met them courageously and would not admit defeat. Such as these Madonnas of the West are the salt of the earth.

Clay W. Vaden. "One of the Last Women Prospectors at Kingston." Kingston, September 1936. [18]

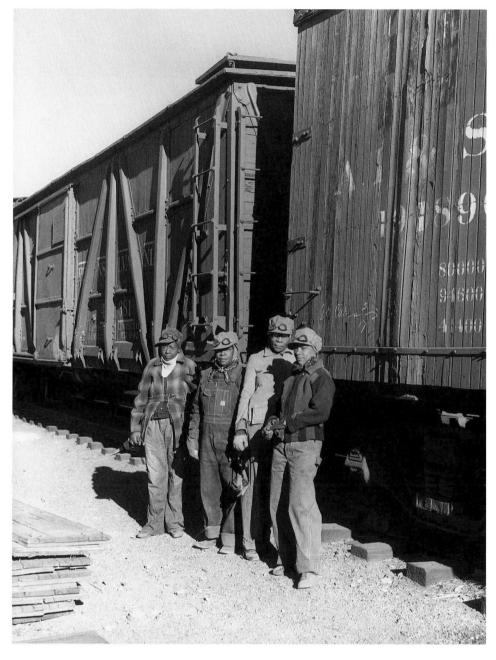

68. Clovis, March 1943. "Left to right: Almeta Williams, Beatrice Davis, Liza Goss and Abbie Caldwell, employed at the Atchison, Topeka and Santa Fe railroad yard to clean out potash cars." Another caption (LC-USW 3-20603-E) reads: "Mrs. Caldwell's husband works in the roundhouse and her son is in the army." Jack Delano. LC-USW 3-20434-D.

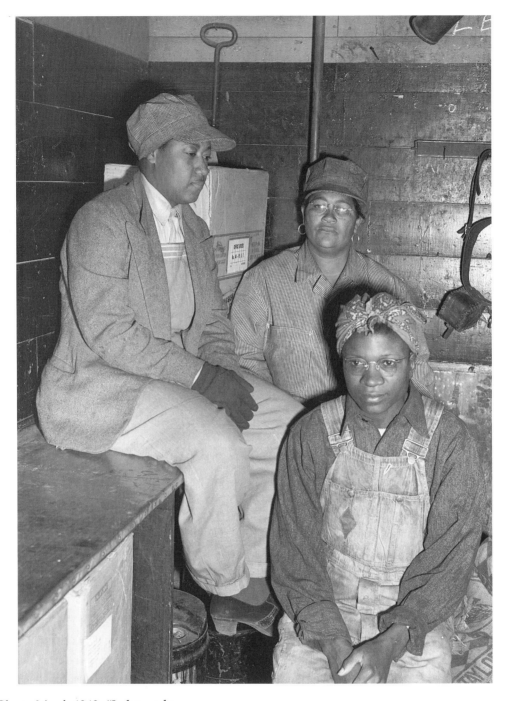

69. Clovis, March 1943. "Left to right:
Lorraine Panol, Felecia Jones and Vera
Edmore, car cleaners employed at the
Clovis yard of the Atchison, Topeka and
Santa Fe railroad." Jack Delano. LC-
USW 3-20466-D.

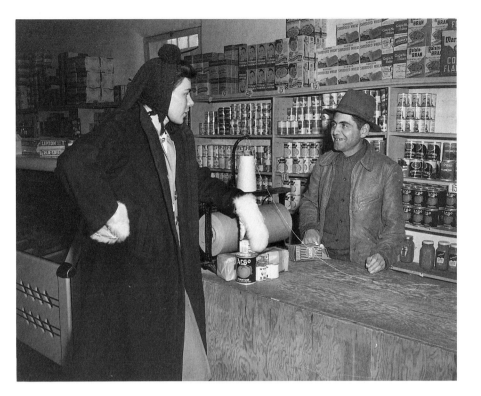

70. Peñasco, January 1943. "Nurse of the clinic operated by the Taos county co-operative health association doing her shopping." LC-USW 3-18033-C shows Marjorie Muller chopping wood and identifies her as a "Red Cross resident nurse at the clinic operated by the Taos county co-operative health association [Reid 1946] does her own cooking, cuts her own wood and draws her own water." John Collier, Jr. LC-USW 3-14565-C.

71. Pie Town, June 1940. "Mother [Mrs. Holley] and daughter [Lois Stagg] working in the cafe kitchen. The daughter, with her husband runs the cafe." The front of the Pie Town Café, with Lois Stagg washing the windows, is shown in LC-USF 34-36773 (Wood 1989:67). Russell Lee. LC-USF 34-36605-D.

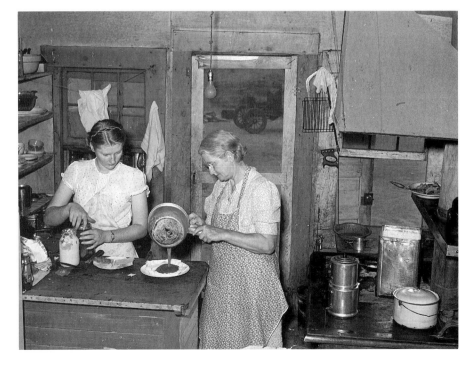

HAIR DRESSING

TWO TAOS CITIZENS had made an appointment with one of the prominent members of the Taos Pueblo Indians for an amole shampoo. Sufficient notice had been given so that the soap-weed root could be soaked overnight. During the shampoo, the conversation turned to the beautiful black hair of the Indians and why they did not turn gray—except in rare instances. Those who are gray are usually very old.

Juanita Luhan suggested that perhaps it was because the hair was washed only in cold water—and then spoke glowingly of her grandmother who was very, very old and still had coal black hair. "You know, we Indians believe, that if as a child your head is rubbed with the blood of a black crow that you will never have gray hair—that was why my grandmother never became gray!"

Muriel Haskell. "Why the Indians' Hair Stays Black." Taos, August 1936. [19]

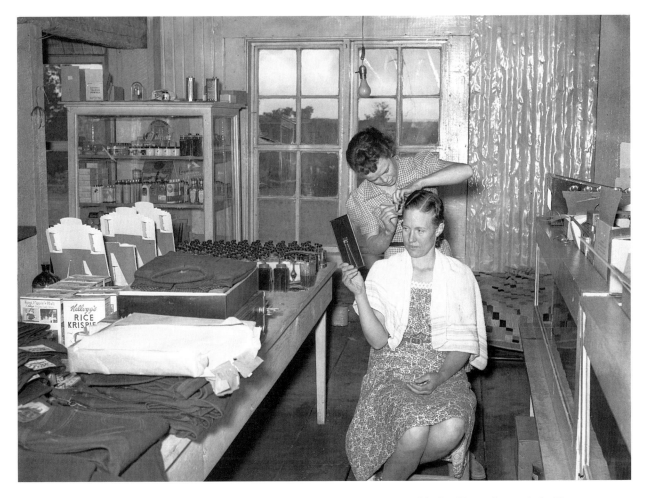

72. Pie Town, June 1940. "A neighbor fixing the grocery clerk's hair." Caption in Wood (1989:57): "Roberta Emery, left, fixes the hair of her neighbor, Etta Mae McKee, in a corner of the grocery store. Since there is no beauty shop for eighty miles, all the women take turns fixing each others' hair." Russell Lee. LC-USF 34-36748-D.

M O T H E R J U L I A N , H O T E L K E E P E R

. . . ONE OF THE GREAT characters still living in Capitan is Mother Julian, who runs a hotel at that point. The oldtimers and cow-punchers stop with her whenever opportunity affords, and she is the friend of them all. You who do not know her and are interested in amusing anecdotes, hasten ye to Capitan, and arrange to stay a few days, then pin back your ears and listen.

I met her just after a car accident when the car insisted on leaving the road during a heavy rain storm, turning bottom side up in a deep arroyo. After kicking out the windshield I got my wife and niece out, and a passing car took us to Mother Julian's hotel. Her first greeting was a word of sympathy, and showing us a room, inquired if we were not pretty well shaken up, remarking, "I wish I had a drop to give you, but come to think of it when Tom Gray left this morning I saw him put something under the counter downstairs, and you"—pointing to me—"run down and see what it contains." It did! It contained a bottle of just the right formula to relieve shock and nerve strain.

Mother Julian is short and ample, with her hair cut close like a man's, no frills on the side that need curling. After supper and the necessary chores attended to, and usually surrounded by old cronies, a tactful question or two will get her started on a line of reminiscences, which if you can go without sleep, may last until morning.

These recollections of hers, which I heard the first night while there, so impressed themselves that I shall try and retell them here. But in so doing they miss the gestures and expression which she alone is capable of. One of her stories concerns a marriage or two and how she handled her husband. Her first was a man named Julian, a man with a good education, but at last she lost him, and although later married to a prospector named Wells she thought so much of her former incumbent that she retained his name.

The man named Wells would borrow all the cash from her and his friends that was possible, load up his burros with food and whiskey—principally whiskey—and disappear to find the richest gold mine that was ever discovered.

As it afterwards proved, Wells would go a few miles from town to where there was a convenient spring and camp. When the supplies were gone he would return with some samples of ore he had picked up, and spend the next week or so bragging about his mine.

On the strength of the samples brought in, he was able for some time to get grub-stakes, but like all good things these eventually came to an end.

After his sources of supplies were cut off, Wells' days of prospecting ended, and he was perfectly contented to sit in an occasional game of poker, drink whiskey—when he could get it—and roost on the wood box behind the kitchen stove, his wife doing the cooking, making the beds, waiting on the table, and tending the hotel office.

Mother Julian never complained, until one time he became abusive and threatening. What happened she describes as follows. "I had a full house as it was Christmas day, every room taken, and I had to set the table three times in order to feed them all. At the last table were a lot of high-toned people, tourists I guess, who although nice enough, seemed a little fussy and I did not want anything to happen to spoil their dinner.

"My old man had been drinking all the morning, mostly the free Tom and Jerry's the saloons were furnishing, and when he came back to the hotel he was whiskey mean.

"I closed the door from the kitchen into the dining room, and slammed him down on the wood box behind the stove, and told him to sit there and shut up. Then he begged me for ten dollars, again I told him to shut up. He then threatened if I didn't give him the money he would beat me, but I grabbed the ax and he sat down and kept quiet. Every time I'd pass him he'd whisper, 'Mother, give me ten dollars or I'll beat you.' As there was a dance on that night all the ranch people had left their babies with me to look after. I was on the jump, waiting on the table and keeping the twenty odd babies quiet.

"For dessert I had served for the first and second tables three kinds of pie, but for the tourists I had in the oven a big egg custard. It was in a big pan that held some two gallons. I came down stairs from tending the babies and had taken away the empty plates, telling the folks I would bring in their dessert. After they all had been served I started to the kitchen with the container, which was still about half full of sticky egg custard. As I entered the kitchen and closed the door behind me, there stood Wells with a big stick of wood in his hand. 'Give me that ten dollars, you hear me? I want it right now.' Down I came on his head with that big pan, custard and all, and crumpled him flat."

"What became of him," I asked. "Well, the last I heard of him," she replied, "he had taken his burros and left for the hills, anyway, I divorced him and took back my first husband's name. God bless him!"

N. Howard (Jack) Thorp. From "Salau or Capitan."
Capitan, December 1936. [20]

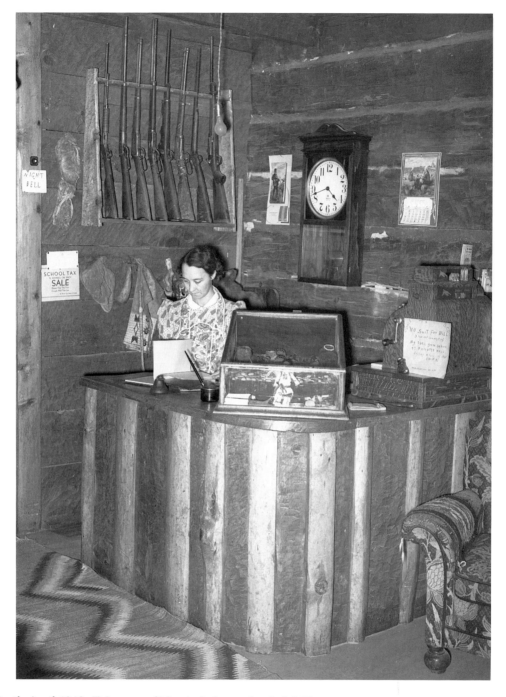

73. Datil, April 1940. "Manager of Navajo lodge at the desk." The caption for LC-USF 34-35886-D reads: "Navajo Lodge formerly an old ranch house in the mountains. About thirty years ago the rancher [Ray Morley] who owned it had it dismantled and moved it piece by piece and rebuilt it at its present location. He is now dead and the house is used as a hotel principally for summer visitors" (Weigle 1985:67, also 68, 69). Russell Lee. LC-USF 34-35891-D.

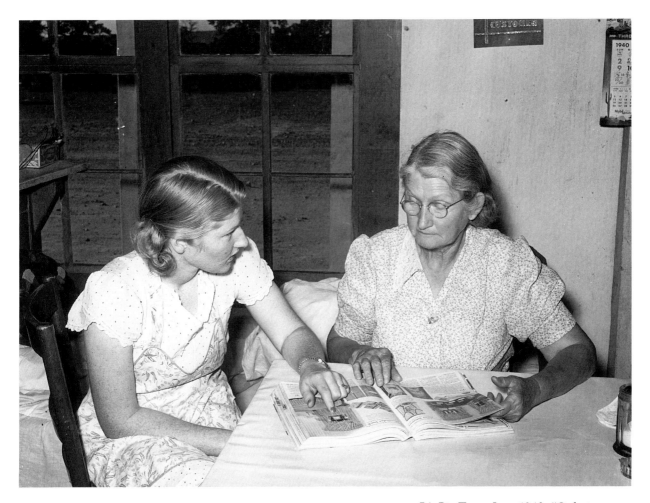

74. Pie Town, June 1940. "Ordering from Sears Roebuck catalogue. Because of the distance to the nearest stores, practically all household equipment and bought clothing is ordered from mail order houses." Russell Lee.
LC-USF 34-36963-D

THE TAPALO, OR BLACK SHAWL

NOWADAYS WITHOUT MUCH notice, and with perhaps undue haste, styles of wearing apparel pass into oblivion. It was not so in the old days, as those of the generation that saw the hoop-skirt of the eighties and the "mutton-chop" sleeve of the nineties can attest. The successive changes in milady's wardrobe were not so transitory then as now yet they did change after a certain length of time.

One garment, however, withstood with tenacity for quite a long period of time those rapid changes. This was the *tapalo*, or black Spanish shawl, worn by Spanish-American women for many years after its introduction into this section of the state by the early settlers. Its use was general among Spanish-Americans up to about the year 1920. Very few of these old shawls are now worn, and these only by the older women, the younger women and the girls of today having discarded it altogether for modern clothing. Most of them are now kept as mementoes of bygone days, carefully folded among the mothballs in the family trunk. An expensive *tapalo*, in years past was the pride of every Spanish American woman who owned one and the envy of her less fortunate feminine neighbors.

Tapalos were imported from Spain and the distributing agency for them was located in New York City. The best grade was made of fine worsted woolen yarn, the cheaper grades of a mixture of wool and cotton. They had a silk fringe on all four sides. In some stores the retail price was proportionate to the grade of the cloth but in most stores the price was fixed according to the length of the fringe—the longer the fringe, the higher the price. As the display of a long fringe was considered most important by the wearer of a *tapalo* no amount of persuasion by a store-clerk could induce a woman to buy a shawl of higher quality in preference to one of a cheaper grade, if the fringe of the former was shorter than the fringe of the latter.

Most women owned two shawls, a cheap one for everyday wear, and an expensive one for special occasions. The expensive one was kept in the owner's trunk, carefully folded. When occasion offered it was cleaned and pressed, and the wearer stepped out into public observation with a swish and grace of movement not customary to her usual gait. In later years the fringes on the better grades of these shawls were woven into extra-fancy designs, making the shawl much more attractive and considerably higher-priced.

On the regular day of the monthly church service when the priest visited

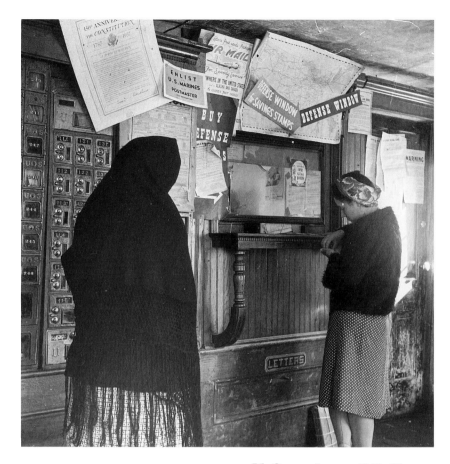

75. Questa, January 1943. "Post office." John Collier, Jr.
LC-USW 3-18101-E.

each village, the passing of groups of black-shawled women on their way to church offered an opportunity to view a good display of fancy tapalos. At the church the assembly of black-hooded women (shawls were worn covering the head, as well as the upper part of the body) kneeling or sitting on the bare floor (there were no seats in the churches in those years) lent an added air of sanctity to the service, and on funeral service occasion, a gloomy aspect of mourning.

The final passing of the *tapalo* will mark an epoch in the history of feminine wearing apparel in northern New Mexico.

Reyes N. Martínez. "The Passing of the Tapalo."
Arroyo Hondo, April 1937. [21]

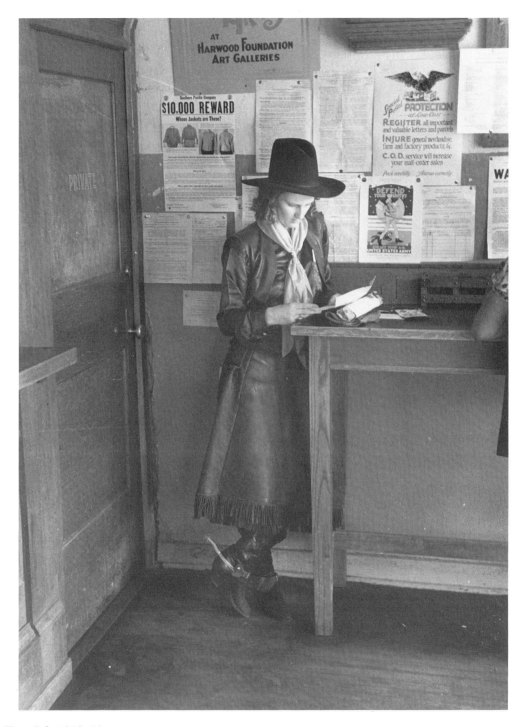

16. Taos, July 1940. "A visitor at
the fiesta." Russell Lee.
LC-USF 33-12848-M3.

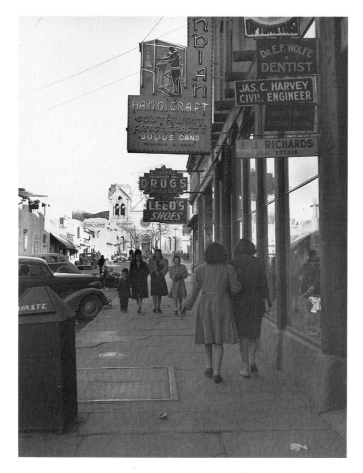

77. Santa Fe, February 1943. (On
the south side of the plaza looking
east on San Francisco Street
toward La Fonda and St. Francis
Cathedral.) John Collier, Jr.
LC-USW 3-19237-C.

RODEO CELEBRITIES

QUEMADO, CATRON COUNTY, New Mexico, might well be called "The Rodeo Center of New Mexico," because of its rodeo colony of celebrities living up picturesque Largo canyon south of the town within a radius of from ten to twenty miles.

Among the rodeo performers of national fame residing near Quemado are: Donald Nesbitt, former world champion all-around cowboy; Walter Heacock and his brothers, Steve and Chuck; Don Nesbitt's young protege, Dick Griffith, top-notch fancy trick rider and Brama bull rider; Eleanor Heacock, one of America's best lady trick riders who was a headliner with Ringling Brothers Circus all last year (in private life now Mrs. Eleanor Cline, one of Catron county's most prominent ranch owners). These rodeo stars are among the best in the United States and they travel everywhere partaking in the big rodeos at Tucson, Arizona, Boston, Madison Square Garden and elsewhere, winning fame for themselves and for their home land, New Mexico, The Sunshine State.

Clay W. Vaden. "Quemado, Home of Rodeo Stars." Quemado, November 1936. [22]

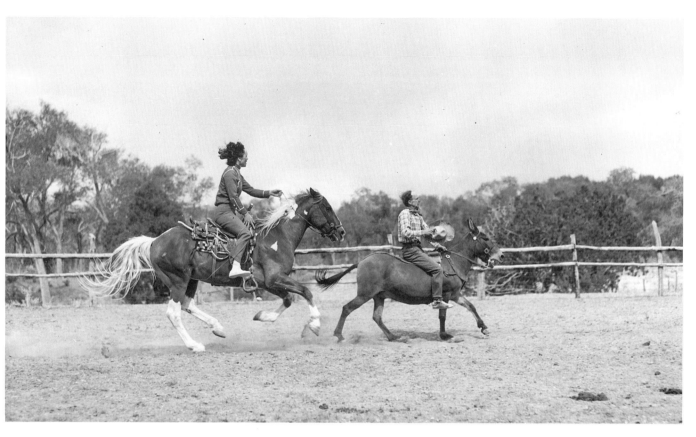

78. Quemado, June 1940. "Trick riding at the rodeo." Russell Lee. LC-USF 34-36950-D.

S E P T E M B E R S A N G E R O N I M O D A Y
F I E S T A S , T A O S

THE SOUND OF THE tom tom and chanting and dancing marked the conclu-
sion of the race and the spectators made ready to make their way [from Taos
Pueblo] to the village of Don Fernando. In the few minutes following, the
two roads that led from the pueblo to the village of Taos were marked by clouds
of dust as every one scurried along towards the old village.

At the pueblo, even before the races were over, several boys and young men
had already been busy, selling tickets among the throngs of people, on com-
mission for a ride on *"Los Caballitos"* (Spanish—little horses), the merry-go-
round, which made the main attraction during the day in the old plaza. The
arrivals at the plaza were greeted by the music of the cornet band-box of the
merry-go-round, as it revolved with the circular platform and the merry riders
that rode the wooden horses and the seats. The merry-go-round was put up
on some vacant lot in the vicinity of the park. Ten cents each, three for a
quarter, was the price for adults, and five cents each, or six for a quarter, the
children's fare

The San Geronimo dances at Taos hall and at the old court house con-
cluded the San Geronimo celebrations. At the Taos hall the elite of Society
of the region attended; those in the lower category, at the court house. This
was the one occasion of the year for an extra-special display of finery in dress
and jewelry, also for the time of their lives for the young people that had come
from afar. Taos hall was especially famous all over New Mexico and southern
Colorado.

*Reyes N. Martínez. From "San Geronimo Celebrations during the
Nineties." Taos, January 1937.* [23]

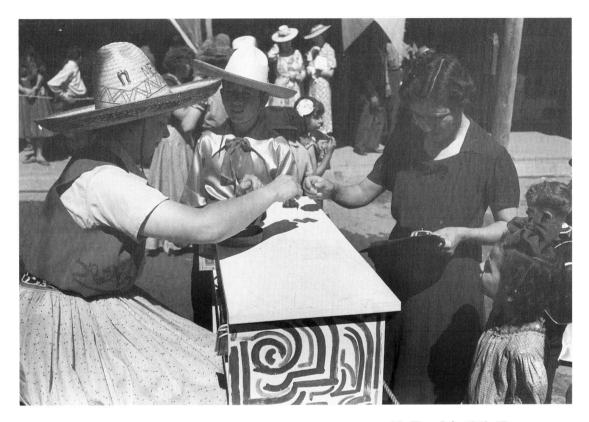

79. Taos, July 1940. "Buying a
ticket for the merry-go-round at
the fiesta." LC-USF 33-12847-M4
shows a sign, "Fiestas for 1940,"
reading: "July, 25th. and 26th.
Santiago Santa Anna and Taos
Fiesta Days" (Weigle and White
1988:402). Russell Lee.
LC-USF 33-12881-M2.

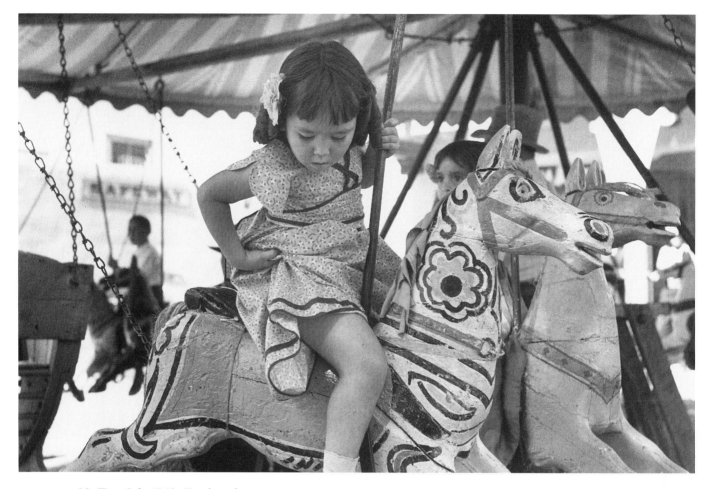

80. Taos, July 1940. "Little girl on
the merry-go-round horse at the
fiesta." For a full view of this "old
merry-go-round during the
fiesta . . . reputed to be the oldest
merry-go-round in America," LC-
USF 33-12869-M2, and a brief
history of it (known in Taos as Tio
Vivo), see Weigle and White
(1988:403). Russell Lee.
LC-USF 33-12847-M3.

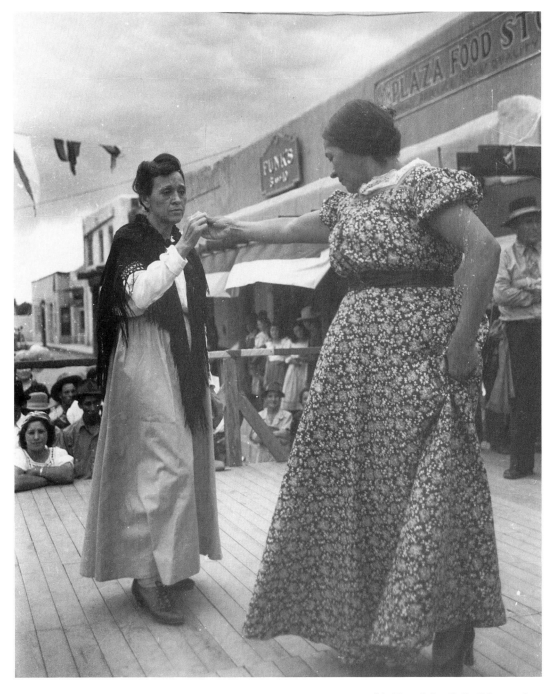

81. Taos, July 1940. "Native dance at the fiesta." For additional views of this dancing and the musicians see Weigle and White (1988:190-91). Russell Lee. LC-USF 33-12869-M4.

G O O D T I M E S
I N T H E G O O D O L D D A Y S

. . . THEY HAD GOOD times in the old days [in Anthony]. "Innocent fun," Mr. Geck called it. "We had picnics, barbecues, dances, chuck wagon suppers and rodeos. The last rodeo was staged about eight years ago by a group of old timers, and the last chuck wagon supper ten or eleven. The good old days when we took our guitars and sang love songs to the girl of our dreams will never return. Pretty soon the mothers will be like the girls and buy all of our native dishes in tin cans."

Marie Carter. From "Old Timers Stories—Charles C. Geck (Wife: Ramona Geck)." Anthony, May 1937. [24]

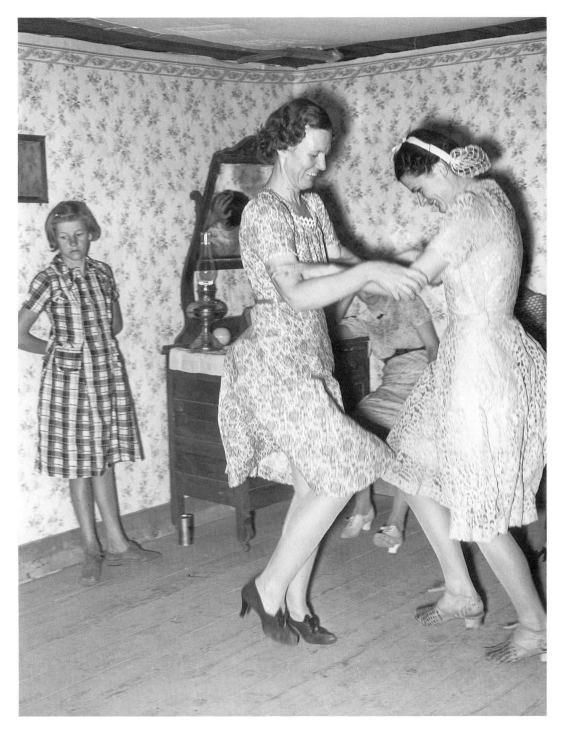

82. Pie Town, June 1940. "The square dance."
Caption in Wood (1989:64): "Etta Mae McKee, left,
dances with an unidentified partner at Bill Stagg's
party." For additional views of this dance see Ganzel
(1984:86-87) and Weigle and White (1988:204, 206,
207). Russell Lee. LC-USF 34-36870-D.

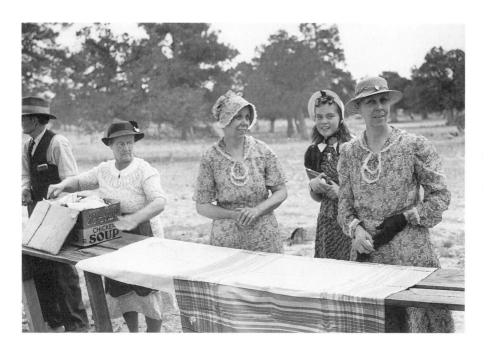

83. Pie Town, June 1940. "Farm women getting dinner ready at the all day community sing." Russell Lee. LC-USF 34-36914-D.

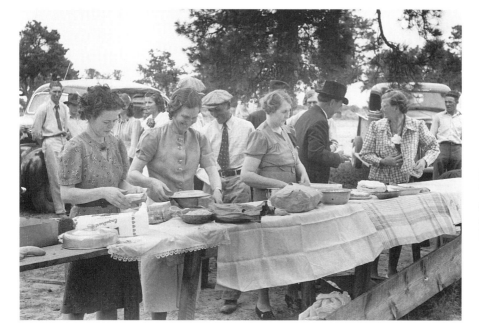

84. Pie Town, June 1940. "Putting out the food for dinner at the community sing." Russell Lee. LC-USF 33-12763-M3.

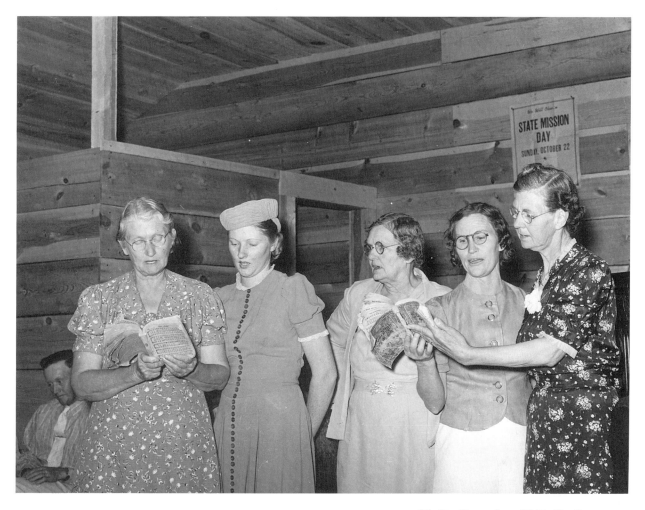

85. Pie Town, June 1940. "Ladies quintette at the community sing." For additional views of this all-day community sing at the Baptist Church see Weigle and White (1988:183) and Wood (1989:60). Russell Lee. LC-USF 34-36954-D.

THE *ENCUENTRO* OF JESUS AND THE VIRGIN MARY, GOOD FRIDAY

. . . ON THE MORNING of Good Friday, the call to prayers is sounded from the roof of the church, not by the sweet tones of the bell, *Maria Antonia*, but by a *matraca* [rattle] in the hands of a [Penitente] Brother. No bells are ever heard on this day. It is the day on which Our Lord was crucified, and sorrow dominates the scene.

After the prayer service, a sense of preparation is evident around the church. Black-shawled women gather inside the churchyard as if in expectancy of some summons. The Brother atop the church suddenly sounds his rattle. The women flock inside, take down the figure of the Virgin Mary, one of the most sensitively and beautifully fashioned of New Mexican *santos de bulto*, and place it on a pedestal. The hymn to the Virgin is begun, and the rest of the people fall in line as the image is carried slowly toward the door. Some of the women following the image are barefoot and weeping. This procession makes its way across the churchyard, pausing now and then for prayer, after which the singing is resumed.

From the direction of the *morada* [Brotherhood meetinghouse], a voice is heard intoning, as if reading some very impressive sermon, with the noise of the *matracas* intruding now and then. As the figure of the Virgin with its attendant group of women nears the *Puerta de la Plaza*, the Brethren round the corner of the narrow passageway. The two groups slowly move toward each other.

In the fore of the Penitente group is a boy, one of the youngest of the Brethren, holding in his arms the figure of Christ on the Cross, the blood-bespattered image known as *Nuestro Padre Jesús*. Behind him are the two singers, but they are silent in this procession. A diminutive figure with misshapen legs, almost dwarflike in his proportions, is reading in a sonorous voice *La Pasión del Señor*. As the two groups meet, the reading of this dolorous account of Our Lord's suffering and His humiliating path of anguish to the Mount of Calvary has just reached the point where the meeting of Christ and His Mother is described. Behind the reader follows a blindfolded figure, naked to the waist, who carries a small cross strapped to his shoulders, with his outstretched arms bound tightly to its horizontal piece.

The women break into soft weeping as they experience the anguish of the mother meeting her son under such sorrowful conditions. They move forward to kiss the feet of the figure on the cross, uttering piteous exclamations of sorrow at such suffering. The penitent with the cross strapped to his back drops to his knees, remaining thus for the rest of the ceremony.

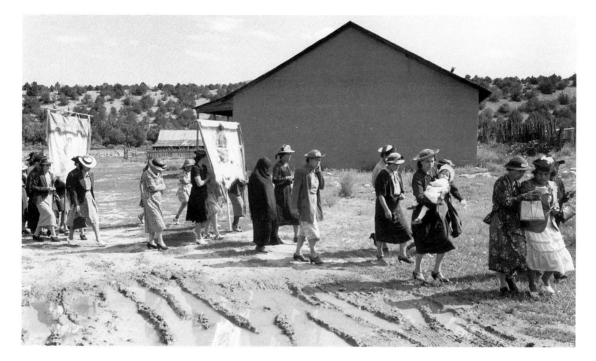

86. Peñasco, July 1940. "Procession of Spanish-American Catholics in
honor of a saint." LC-USF 34-37147 shows the beginning of this pro-
cession as it passes the church: "The women in the front carry a ban-
ner displaying the image of Our Lady of Carmel, which suggests that
it is her feast day, July 16, and that these women are *carmelitas*,
members of the lay order dedicated to this advocation of Our Lady.
The second banner [center of this picture] displays Our Lady of
Guadalupe and the third is another image of the Blessed Virgin [on
left herein]" (Wroth 1985:113). Russell Lee. LC-USF 33-12802-M4.

The women who have carried the figure of Mary are for the most part
members of the Order of Our Lady of Mount Carmel, to which group belongs
the honor of carrying the beloved image of the Virgin on this occasion. The
rest of the women are housewives, none of whose family belong to the
Penitentes. As the words *"cara a cara"* are sung, the figures of Mother and
Son are raised so their cheeks touch and they appear in a sorrowful last embrace.

The women with the Brethren are their own wives, mothers, and sisters;
many of them are barefoot also. They and the Brothers render obeisance to
the Virgin, kissing the hem of her gown and prostrating themselves before
her. This ceremony is called *El Encuentro*, the meeting of Christ and the Virgin
Mary on the *Vía Dolorosa*, in Jerusalem. The reading of "The Passion of Our
Lord" continues as the two groups merge and enter the church. Here, the figure
of the Crucified Christ is returned to the center of the altar. He is home
again

Lorin W. Brown. From "Lent in Córdova." Córdova, n.d. [25]

NOTES ON THE TEXTS

New Mexico Federal Writers' Project/Program (NMFWP/WP) manuscripts included herein are identified as fully as possible by title, collector, informant(s), date of writing, sometimes date of receipt in the Santa Fe editorial office, and the location(s) of the documents. The following abbreviations are used:

A#: Works Progress Administration (WPA) Files at the New Mexico State Records Center and Archives (NMSRC). The 30 expandable files of 268 folders have been indexed by archivist Louellen N. Martínez as of July 18, 1983.

AHT: Number assigned in "Inventory of Annette Hesch Thorp's Writers' Program Manuscripts" (Weigle 1983:99-102).

BC: Number assigned in a preliminary compilation by Gilberto Benito Córdova, *Bibliography of Unpublished Materials Pertaining to Hispanic Culture in the New Mexico WPA Writers' Files* (Santa Fe: New Mexico State Department of Education, December 1972). Some NMSRC documents are filed by BC numbers.

H#: Materials at the History Library, Museum of New Mexico, Santa Fe, originally were filed by file cabinet, drawer, and folder numbers; most remain so. A card catalogue for many of these documents was assembled in the 1970s, but it has not been updated.

HC: The alphabetical city files at the History Library, Museum of New Mexico, Santa Fe.

LC: Ann Banks of the American Studies Center, Boston College, compiled a "Survey of Federal Writers' Project Manuscript Holdings in the Archive of Folk Song, Library of Congress," dated December 28, 1979, when the holdings were under the care of the Folksong Archive (now Archive of Folk Culture, American Folklife Center). Manuscripts are numbered by file and drawer, from 36.2 to 48.4, as they are herein. These holdings are now in the Manuscript Division of the Library of Congress, where another group of FWP documents was released from the Library's Landover warehouse. Those holdings were examined in June 1981 and are listed here as LCms#, indicating file boxes but not individual folders.

LWB: Number assigned in "The Basic Corpus of Lorin W. Brown's Manuscripts" (Brown 1978: 260-64).

1. "Customs and Conditions of Early-Day Ranch Life," coll. Mrs. Benton Mosley of Lovington from her own observations and personal experience; "traditional knowledge of the section"; E. H. Price, Palma, New Mexico; Mrs. John Causey, Inglewood, California; B. Oden, Pecos, Texas; Chas. Fairweather and Bob Beverly, both of Lovington, New Mexico; 1400 wds., 7 pp., 16 November 1936 (A#9:97, 12:118). An edited version of the text appears in Mosley (1973: 38-39, 40), a chapter entitled "The Plains Country and Its Early Homes."

2. "Jesu' Cristo a Caballo," coll. Lorin W. Brown; 1012 wds., 4 pp., 22 November 1937 (BC227; H5-5-26#16; LWB73). Published as "Santo a Caballo," *The Santa Fe New Mexico Sentinel*, 29 December 1937, p. 6. The text used here is reprinted in Brown (1978:97).

3. "Catalina Viareal," coll. Annette H. Thorp of Santa Fe; 1074 wds., 5 pp., 17 September 1940 (AHT3; H5-5-52#68). The text used here is reprinted in Weigle (1985:9-11).

4. "Lina," coll. Annette H. Thorp; 623 wds., 3 pp., 31 December 1940 (AHT8; H5-5-52#74). An edited version of the text is on pp. 234-35 of "Some of Tía Lupe's Contemporaries: True Stories of Some New Mexico Grandmothers," n.d. (AHT17; AHT22a; BC17).

5. "Cooperation," coll. Reyes N. Martínez; 1004 wds., 5 or 6 pp., 20 and 27 February 1937 (A#24:

233; BC473; H5-5-50#3; LC47.1; LCms#3).

6. "Chana," coll. Annette H. Thorp; 783 wds., 3 pp., 8 October 1940 (AHT5; H5-5-52#71).

7. "Unusual Industries," coll. Genevieve Chapin from the Lawton Carrolls of Clayton; 2100 wds., 10 pp., 25 July 1936 (A#238; LC47.1). The text used here is reprinted in Weigle (1985:107-108).

8. "Customs and Conditions of Early Ranch Life (Continued from last week)," coll. Mrs. Benton Mosley "almost wholly from the writer's memory of well known local traditions, which were family traditions as well; the actors or participants of the incidents recounted can be named, if desired"; 1500 wds., 8 pp., 23 November 1936 (A#9:97, 12:118). An edited version of the text appears in Mosley (1973: 42-43), a chapter entitled "Everyday Life on Early Ranches."

9. "Lina," continuation of 4 (above), coll. Annette H. Thorp; 527 wds., 3 pp., 7 January 1941. The edited version of this text is on pp. 235-36 of "Some of Tía Lupe's Contemporaries."

10. "Customs and Conditions of Early Ranch Life (Lea County)," coll. Mrs. Benton Mosley from "local tradition, family tradition as well, and written almost wholly from the writer's memory" and from Mrs. E. C. Causey, 534 Brett St., Inglewood, California; Mrs. E. H. Price, Palma, New Mexico; Mrs. Nancy Dunnaway, Lovington; Mrs. Annie Brunson, Stanton, Texas; Mr. Jake Owen, Carlsbad; Mrs. C. C. Medlin (now deceased); and Mr. Chas. Fairweather, Lovington; 2900 wds., 13 pp., 7 December 1936 (A#9:97, 12:118). An edited version of the text appears in Mosley (1973:32-33), a chapter entitled "Customs of Early-Day Ranch Life."

11. "Tía Lupe," coll. Lorin W. Brown, 8 pp., n.d. (A#20; BC20; LC47.1; LWB116). Brown's earliest dated NMFWP ms. is a 2-page sketch, "Tía Lupe" (H5-5-26#11; LC38.1; LWB117), an account edited and published in the short-lived, mimeographed NMFWP periodical, *Over the Turquoise Trail* 1, 1 (1937): 31-32. The present version comprises pages 96-103 of an anonymously edited, undated (1940-41), unfinished ms., "Deep Village, the Story of Córdova, New Mexico" (Weigle 1983:94; also see 4 and 8, above). The text used here is reprinted in Weigle (1987:2, 6-7) and also in Brown (1978:129, 136-37).

12. "Customs and Conditions of Early Ranch Life (Lea County)," coll. Mrs. Benton Mosley (see 10, above). The edited version appears in Mosley (1973:34).

13. "Mrs. Lena Kempf Maxwell, School Teacher & Museum Manager, Clovis, New Mexico," coll. Mrs. Belle Kilgore; 1150 wds., 6 pp., 26 June 1937 (A#192; LC47.1). The text used here is reprinted in Weigle (1985:169, 170).

14. "The Black Dog," coll. Lorin W. Brown; 1720 wds., 5 pp., 2 July 1937 (BC208; H5-5-50#10; LWB 32). The text used here is reprinted in Brown (1978:75).

15. "Customs and Conditions of Early Ranch Life (cont'd) (Lea County)," coll. Mrs. Benton Mosley: "from the actual knowledge and memory of the writer. A few instances there are when the memory is of the stories of the happenings heard over and over from old timers here. Especial acknowledgment is made to the following for their contributions: Pat Brady, Chas. Fairweather, Joe D. Graham, and Eliza Graham, of Lovington, N. Mex. Also to E. H. Price, Palma, N. Mex. and Henry Cummins, Midland, Tex."; 2800 wds., 12 pp., 21 December 1936 (A#9:97, 12:118). An edited version of the text appears in Mosley (1973:23-24), a chapter entitled "Conditions of Early-Day Ranch Life."

16. "The Knitter and the Burro," coll. Reyes Martínez from Francisco Vigil of Arroyo Hondo; 510 wds., 2 pp., 20 March 1937 (BC412; H5-5-47#19; LC38.1, LC47.1, LC47.2).

17. "Mrs. Fannie Potter," from "Unusual Industries," coll. Genevieve Chapin from the Potters of Clayton; whole ms., 2100 wds., 10 pp., 25 July 1936 (A#238; LC47.1). The text used here is reprinted in Weigle (1985:107).

18. "One of the Last Women Prospectors at Kingston," coll. Clay W. Vaden; 216 wds., 1 p., 1 September 1936 (H5-5-53#19; LC47.2). The text used here is reprinted in Weigle (1985:56).

19. "Why the Indians' Hair Stays Black," coll. Muriel Haskell from Majel G. Claflin, an artist on the New Mexico Federal Art Project; 1 p., 14 August 1936 (H5-4-12#1; BC321; LC47.2; LCms#6). The text used here is reprinted in Weigle (1985:98).

20. "Salau or Capitan," coll. N. Howard Thorp;

1500 wds., 6 pp., 23 December 1936 (HC:Capitan; LC47.1). The text used here is reprinted in White and White (1988:52-54) and also appears in Weigle (1985:131-33).

21. "The Passing of the Tapalo," coll. Reyes N. Martínez; 2-5 pp., 10 and 20 April 1937 (BC437; H5-5-47#27; LC38.1, LC47.1, LC47.2; LCms#4). The text used here is reprinted in Weigle with Powell (1982:71-72).

22. "Quemado, Home of Rodeo Stars," coll. Clay W. Vaden; 165 wds., 1 p., 16 November 1936 (A#18:182). Also reprinted in White and White (1988:204).

23. "San Geronimo Celebrations during the Nineties," coll. Reyes N. Martínez from personal knowledge; 11 pp., 30 January 1937 (A#5:50; BC461; H5-5-47#34; LC47.1; LCms#4). The text used here is reprinted in Weigle and White (1988:403-404).

24. "Old Timers Stories—Charles C. Geck (Wife: Ramona Geck)," coll. Marie Carter on May 17, 1937; 1300 wds., 5 pp., 24 May 1937 (A#20:197; HC:Anthony; LC38.1, LC47.1). The text used here is reprinted in Weigle (1985:62).

25. "Lent in Córdova," coll. Lorin W. Brown; 16 pp., n.d. (A#14:141; LWB75). Pages 72-93 of an anonymously edited, undated (1940-41), unfinished ms., "Deep Village, the Story of Córdova, New Mexico" (Weigle 1983:94; also 11, above). The text used here is the slightly revised version published in Córdova (1972:44-45).

APPENDIX:
THE FEDERAL PROJECTS,
THE PHOTOGRAPHERS
AND THE WRITERS

The Federal Projects

Farm Security Administration (FSA): First established on April 30, 1935, as the Resettlement Administration, it was an independent agency to provide short-term relief for impoverished farm families and long-term rural rebuilding. It became part of the U.S. Department of Agriculture on January 1, 1937, and the name was changed to the FSA on September 1, 1937. Roy Emerson Stryker (1893-1975) officially joined the Resettlement Administration on July 10, 1935, as Chief of the Historical Section with a broad mandate to direct investigators, photographers, economists, sociologists and statisticians. He set up an Information Division to provide unified photographic services and eventually employed photographers like Arthur Rothstein, Carl Mydans, Walker Evans, Ben Shahn, Dorothea Lang, Paul Carter, Theodor Jung, Russell Lee, John Vachon, Marion Post Wolcott, Jack Delano, and John Collier, Jr. By September 1942 Stryker and his staff were doing work for the Office of War Information (OWI), no longer able to document the rural and urban poor but instead enlisted for war propaganda. Stryker resigned in September 1943 and went to work for Standard Oil, heading a team to document the oil industry's impact on New Jersey and then nationwide. Paul Vanderbilt had begun archiving the 77,000 FSA-OWI prints (some 68,000 related original negatives unprinted) in 1942, and they were transferred to the Library of Congress in 1944 and 1946.

Selected References

Curtis, James. *Mind's Eye, Mind's Truth: FSA Photography Reconsidered.* Philadelphia: Temple University Press, 1989.

Daniel, Pete, Merry A. Foresta, Maren Stange, and Sally Stein. *Official Images: New Deal Photography.* Washington, D.C.: Smithsonian Institution Press, 1987.

Dixon, Penelope. *Photographers of the Farm Security Administration: An Annotated Bibliography, 1930-1980.* New York: Garland Publishing, 1983.

Fisher, Andrea. *Let Us Now Praise Famous Women: Women Photographers for the US Government 1935 to 1944.* London and New York: Pandora Press, 1987.

Fleischhauer, Carl, and Beverly W. Bannan, eds., with essays by Lawrence W. Levine and Alan Trachtenberg. *Documenting America, 1935-1943.* Berkeley: University of California Press in association with The Library of Congress, 1988.

Hurley, F. Jack. *Portrait of a Decade: Roy Stryker and the Development of Documentary Photography in the Thirties.* Baton Rouge: Louisiana State University Press, 1972.

Peeler, David P. *Hope Among Us Yet: Social Criticism and Social Solace in Depression America.* Athens: University of Georgia Press, 1987.

Stott, William. *Documentary Expression and Thirties America.* New York: Oxford University Press, 1973. With new afterword, Chicago: University of Chicago Press, 1986.

Stryker, Roy E., and Nancy Wood. *In This Proud Land: America 1935-1943 as Seen in the FSA Photographs.* Greenwich, Connecticut: New York Graphic Society, 1973.

Federal Writers' Project (FWP): Together with the Art, Music, and Theatre projects, a subproject of Federal (Project Number) One, the first of six white-collar work relief programs set up as part of the Works Progress Administration (WPA), the FWP was established on August 2, 1935, to employ writers, teachers, map draughtsmen, photographers, reporters, editors, journalists, librarians and research workers. The major, central program, which underwent many changes, was the production of an American Guide. There were also projects in social-ethnic studies, Negro studies, life histories, various encyclopedias and the collection of folklore. Henry G. Alsberg served as national director. Ina Sizer Cassidy (1869-1956) was hired to direct the NMFWP on October 1, 1935. She was demoted in January 1939 and replaced by Aileen (O'Bryan) Nusbaum, who served from February 1 until August 31, 1939. Writers from four

districts—One (Taos, Colfax, Union, Harding, Quay, Guadalupe, San Miguel and Mora counties), Two (Curry, Roosevelt, Lea, Eddy, Otero, Lincoln, De Baca and Chaves counties), Three (Santa Fe, Rio Arriba, San Juan, McKinley, Valencia, Bernalillo and Sandoval counties), and Four (Socorro, Doña Ana, Luna, Hidalgo, Grant, Catron and Sierra counties)—were responsible to editors and the director in Santa Fe, who, in turn, reported to state WPA and Washington FWP officials.

Selected References

Mangione, Jerre. *The Dream and The Deal: The Federal Writers' Project, 1935-1943.* Boston: Little, Brown, 1972.

McDonald, William F. *Federal Relief Administration and the Arts: The Origins and Administrative History of the Arts Projects of the Works Progress Administration.* Columbus: Ohio State University Press, 1969.

Melosh, Barbara. *Engendering Culture: Manhood and Womanhood in New Deal Public Art and Theater.* Washington and London: Smithsonian Institution Press, 1991.

Penkower, Monty Noam. *The Federal Writers' Project: A Study in Government Patronage of the Arts.* Urbana: University of Illinois Press, 1977.

Writers' Program (WP): As part of the Works Progress Administration's 1939 reorganization into the Work Projects Administration, the Federal Writers' Project became the Writers' Program on September 1, 1939. National director John D. Newsom supervised state and locally supported programs with fewer workers. Charles Ethrige Minton (1893-1976) directed the NMWP, which was terminated late in 1942.

The Photographers

John Collier, Jr. (1913-92): Collier attended the California School of Fine Arts and studied mural painting with Maynard Dixon, Dorothea Lange's first husband. Influenced by Lange's documentary work, he joined Roy Stryker's FSA staff in September 1941, the last photographer hired. He left to join the Merchant Marine and later worked on the Standard Oil Project in Latin America. Collier did commercial photography and moved into anthropology and

photography with studies in Nova Scotia, the Navajo Reservation, Peru and Alaska. He taught at both San Francisco State University and the San Francisco Art Institute.

Selected Reference

Collier, John, Jr. *Visual Anthropology: Photography as a Research Method.* New York: Holt, Rinehart and Winston, 1967. Revised and expanded ed., John Collier, Jr., and Malcolm Collier, with a foreword by Edward T. Hall, Albuquerque: University of New Mexico Press, 1986.

Jack Delano (1914-): Born in Russia and emigrated with family to Pennsylvania. Studied drawing and painting at Pennsylvania Academy of Fine Arts, Philadelphia, and in Europe. Photographed coal mining conditions in Pennsylvania for Federal Art Project in 1939. Joined FSA on May 6, 1940. With his wife Irene photographed New England and southern states. Joined Roy Stryker's Standard Oil project after World War II, then continued work in documentary photography. Directed government television service in Puerto Rico, his home.

Selected References

Day, Greg, and Jack Delano. "Folklife and Photography: Bringing the FSA Home." *Southern Exposure* 5 (1977): 122-33.

Raper, Arthur F., with FSA Photographs by Jack Delano. *Tenants of the Almighty.* New York: Macmillan, 1943.

Dorothea Lange (1895-1965): Born Hoboken, New Jersey, educated New York City. Apprenticed to Arnold Genthe; studied with Clarence White, Columbia University. Worked in San Francisco camera store, 1918; opened portrait studio in 1919, married painter Maynard Dixon in 1920 and became a popular photographer. In early 1930s met University of California economics professor Paul Schuster Taylor and with him began documenting social conditions of poor in California for California Division of Federal Emergency Relief Administration. They moved to Washington to work with the Resettlement Administration and by June 1935 Lange was field investigator, photographer, with Information Division and Taylor was regional labor advisor for California, Arizona, Nevada, Utah and

New Mexico. Lange was hired by Stryker for the Historical Section on September 1, 1935. She married Taylor in December 1935. She lost her FSA job at the end of 1939 and did various wartime documentary works, including Japanese Americans' internment. Illness in 1945 forced her to give up work until 1950s, when she did photographic essays for *Life Magazine* and other publications. Exhibited widely. A retrospective of Lange's work was shown at the Museum of Modern Art in 1966.

Selected References

Lange, Dorothea. "Draggin' Around People." *Survey Graphic* 63 (March 1936): 524-25.

Lange, Dorothea. "Documentary Photography." In *A Pageant of Photography*, ed. Thomas J. Maloney, Grace M. Morley, and Ansel Adams. San Francisco: Crocker Union, 1940.

Lange, Dorothea, with a commentary by Beaumont Newhall. *Dorothea Lange Looks At the American Country Woman.* Fort Worth, Texas: Amon Carter Museum, 1967.

Levin, Howard M., and Katherine Northrup, eds. *Dorothea Lange: Farm Security Administration Photographs, 1935-1939.* 2 vols. Glencoe, Illinois: The Text-Fiche Press, 1980.

Meltzer, Milton. *Dorothea Lange: A Photographer's Life.* New York: Farrar, Straus and Giroux, 1978.

Ohrn, Karin Becker. *Dorothea Lange and the Documentary Tradition.* Baton Rouge: Louisiana State University Press, 1980.

Taylor, Paul S., and Dorothea Lange. *An American Exodus: A Record of Human Erosion.* New York: Reynal and Hitchcock, 1939. Revised ed., New Haven: Yale University Press, 1969.

Russell Lee (1903-86): Born in Ottawa, Illinois, on July 21, 1903, Lee was educated as a chemical engineer at Lehigh University. He married artist Doris Emrick and left his manufacturing plant manager's job in 1929 to study painting at the California School of Fine Arts. After moving to Woodstock, New York, he taught himself photography. Roy Stryker hired Lee for the FSA in the fall of 1936, and he photographed in the Midwest, Ohio Valley, Texas, New Mexico and elsewhere. After divorcing his first wife in 1938, he married journalist Jean Smith, who wrote FSA captions for him. During World War II he joined the Air Force and made aerial photographs. In 1946 he documented Appalachian coal mines for the U.S. Department of the Interior and then joined Stryker's Standard Oil project. Later he was a freelance photographer for major magazines and taught photography at the University of Texas at Austin, where he died on August 28, 1986.

Selected References

Fern, Alan M., and William Wroth. " 'Taking Pictures of the History of Today': Russell Lee's Photography." In *Russell Lee's FSA Photographs of Chamisal and Peñasco, New Mexico,* ed. William Wroth, pp. 121-39. Santa Fe: Ancient City Press; Colorado Springs, Colorado: Taylor Museum of the Colorado Springs Fine Arts Center, 1985.

Hurley, F. Jack. *Russell Lee, Photographer.* Dobbs Ferry, New York: Morgan and Morgan, 1978.

Arthur Rothstein (1915-): Born and raised in New York City. In the fall of 1934, as a senior at Columbia University, worked with Roy Stryker on National Youth Administration money to help him copy pictures for a source book on American farming for the Information Division of the Agricultural Adjustment Administration. Joined Stryker in the Resettlement Administration in July 1935 and set up the darkroom by the end of 1935. Documented Shenandoah Valley, Oklahoma dust bowl, western plains, Midwest and South in 1938. Left in 1940 to work for *Look Magazine.* Returned to work with Office of War Information but joined Army Signal Corps as photographer in 1943. Returned to *Look* after war and became technical director until its demise in 1971, after which he taught photojournalism at Columbia University and began a major national documentary project, sponsored by the Environmental Protection Agency, on pollution.

Selected References

Rothstein, Arthur. *The American West in the Thirties: One Hundred Twenty-two Photographs.* New York: Dover, 1981.

Rothstein, Arthur. *Arthur Rothstein: His Words and Pictures.* New York: American Photographic Book Publishing Company, 1979.

Rothstein, Arthur. *The Depression Years: As Photo-*

graphed by Arthur Rothstein. New York: Dover, 1978.

The Writers

Lorin William Brown (1900-1978): NMFWP and NMWP, 1936-41. He was born in Elizabethtown, New Mexico, on November 22, 1900, of Lorin W. Brown, Sr., a newspaper editor and printer from Iowa, and Cassandra Martinez de Brown of Taos, a schoolteacher. Raised in the Taos area after his father's death in 1901, Brown attended school there and in Sterling, Kansas, where his father's sister lived and taught at Sterling College, which he attended for one year. After World War I he did various jobs, among them working for Albuquerque newspapers. His mother remarried and moved to her new husband, Margarito López's village of Córdova, where Brown later was employed as a schoolteacher from 1922 to 1933. He moved to Santa Fe in 1933, purchased a house on lower Agua Fria Street and married Frances Juanita Gilson on August 21, 1939. They lived in Tesuque and Santa Fe until Brown joined the Office of Postal Censorship after Pearl Harbor. Following World War II he worked at various jobs in California, Idaho, Washington, Mexico, New Mexico, and Alaska, where his wife died on December 26, 1969. In the 1970s Brown divided his time between his children's homes in California and New Mexico. He was working on a manuscript, "Tales of Taos," at the time of his death in Oakland, California, on January 17, 1978, and was buried in Códova on January 21, 1978.

Selected References

Brown, Lorin W., with Charles L. Briggs and Marta Weigle. *Hispano Folklife of New Mexico: The Lorin W. Brown Federal Writers' Project Manuscripts.* Albuquerque: University of New Mexico Press, 1978.

Córdova, Lorenzo de [pseudonym for Brown], illustrated by Eliseo Rodriguez with notes by Marta Weigle. *Echoes of the Flute.* Santa Fe: Ancient City Press, 1972.

Carter, Marie: NMFWP, March-July 1937. A resident of Anthony, she wrote to George W. Cronyn on December 4, 1936 (Record Group 69, National Archives): "I am the widow of a veteran of the World War in need of immediate work. I began my career as a writer twenty years ago, but due to poor health, was forced to give it up at intervals.

"Three years ago I collaborated with an editor, and completed quite a number of short stories and articles. Unfortunately, I was sent to the hospital, and following my recovery was advised to give up writing.

"Since my husbands's [sic] death I have resumed my work and hope to carry on. Since I am trying to support myself and fourteen-year-old son, I am appealing to you to give me an opportunity to make a living. Who has a better right than the widow of a veteran who died to make this a better world for the present generation?"

Chapin, Genevieve: NMFWP, February 1936-October 1939. In her report of February 7-27, 1936, District One Supervisor Muriel Haskell writes: "In Clayton . . . Mrs. Genevieve Chapin . . . has done considerable writing and lived for many years in the community . . . Mrs. Chapin is doing fairly well, altho [sic] there seems to be no great continuity or follow through in her work."

Haskell, Muriel: NMFWP, January 1936-February 1937. In a letter to Washington FWP officials, NMFWP director Ina Sizer Cassidy described Haskell, hired in January 1936 at a non-relief wage of $86.25 per month to serve as Supervisor of District One, the northeastern counties, as "an experienced newspaper woman of a number of years experience in the east, now making her home in Taos [and] for two or three years . . . head of an advertising agency in the middle west, handling the publicity of several large firms." Cassidy claims that when she and her new supervisor travelled through the district in February, everywhere they were welcomed enthusiastically, even by "rabid Republicans."

Kilgore, Belle (Mrs.): NMFWP, January-July 1937. Of 718 Wallace Street, Clovis.

Martínez, Reyes Nicanor (1885-1970): NMFWP, NMWP, February 1936-May 27, 1941. District supervisor Muriel Haskell notes in her February 7-27, 1936, report that Martínez "has lived in the same village since boyhood and is peculiarly able to gather material on the northern villages, folklore and customs—and additional oldtimers stories. [He is] very willing to cooperate in any way—however [his] wordage is not entirely satisfactory." Martínez

submitted more than three hundred manuscripts, many of which were sent to Washington in their original, handwritten form. When he was fired from the NMWP he was working on a collection of *alabados* (hymns) from Taos County.

Born and raised in Arroyo Hondo, where he lived off and on throughout his life until illness forced him to move permanently to California in 1963, Martínez, his wife Matilde Anaya, and the first six of their ten children (the other four were born later) lived in Kit Carson's house in Taos during the early 1930s. Martínez then worked in different city offices. Before and after his FWP/WP employment, he held various jobs in New Mexico, Wyoming, California and other states, always returning to Arroyo Hondo, where he continued to own land and where his brothers Onécimo and Tomás lived. Among his many jobs was work at the roundhouse of the Union Pacific Railroad in Green River, Wyoming, and as night clerk at Anderson's Inn in Buellton, California.

According to Martíinez's "Spanish—Pioneer: The Martínez Family of Arroyo Hondo" (11 December 1936; BC420; A#234; H5-5-47#22; LCms#6): "On January 20, 1851 . . . [his father] Julián Antonio Martínez was born in the little village of Arroyo Hondo, in Taos County A descendant of two of the principal Spanish families of the province, he . . . received the rudiments of his education in the village schools of Arroyo Hondo and later attended Saint Michael's College at Santa Fe

". . . Don Julián, as he later came to be known, started a small general-merchandise store and saloon in one of the rooms of the old home in Arroyo Hondo in 1880—groceries at one end of the room and liquor at the other end His rigorous bringing-up stood him well in his business, as many a night he went without sleep in order to attend his customers in the saloon. His business increased by leaps and bounds and he acquired large holdings of lands and became the owner of extensive herds of sheep and horses, owning also a fair number of cattle. He sent a petition from the people of the village to the Post Office Department at Washington for a post office and was appointed the first postmaster of Arroyo Hondo, a position he held till 1904, when he retired from business and moved to Santa Fe. A significant fact

is that the post office has remained in the old Martínez home and family since its establishment more than fifty-five years ago.

"A stern but loving father, Don Julián gave his children the best of an education, among the schools they claim as their Alma Mater being Denver University, Regis College (both in Denver), the New Mexico Military Institute at Roswell, and the higher schools of Santa Fe

"Of conspicuous prominence in the life-history of Don Julián may be mentioned the wedding of his daughter, Cleofas, to Colonel (he was a member of Governor Miguel A. Otero's staff) Venceslao Jaramillo, a prominent young politician and scion of one of the most wealthy and cultured Spanish families of New Mexico. The ceremonies of this prominent couple lasted several days. The bridegroom rented the whole Barron hotel in Taos for the use of the guests

"Don Julián, now nearing 86 years of age, lives in Santa Fe [at 125 Grant Avenue]. His seven children, five sons and two daughters, also are living. His wife died in 1931." When Cleofas M. Jaramillo died on November 30, 1956, her sister, Mrs. Mae M. Raizizun of El Paso, Texas, and all five brothers—Onécimo G. and Thomas J. of Arroyo Hondo, Reyes N. of San Francisco, and Ben L. and Alfonso D. of Santa Fe—survived.

Selected References

Jaramillo, Cleofas M. *Shadows of the Past (Sombras del pasado)*. Santa Fe: Seton Village Press, 1941. Reprint, Santa Fe: Ancient City Press, 1972, 1980.

Jaramillo, Cleofas M. *Romance of a Little Village Girl*. San Antonio, Texas: Naylor, 1955.

Jensen, Carol. "Cleofas M. Jaramillo on Marriage in Territorial Northern New Mexico." *New Mexico Historical Review* 58 (1983): 153-71.

Shalkop, Robert L. *Arroyo Hondo: The Folk Art of a New Mexican Village*. Colorado Springs, Colorado: The Taylor Museum of the Colorado Springs Fine Arts Center, 1969.

Weigle, Marta. "About Cleofas Martínez de Jaramillo." In Cleofas M. Jaramillo, *The Genuine New Mexico Tasty Recipes: With Additional Materials on Traditional Hispano Food*, pp. 19-20. 1942; reprint, Santa Fe: Ancient City Press,

1981. (Includes two NMFWP pieces by Reyes N. Martínez, "Foods of the Southwest" [31 August 1936] and "Pinon Picking" [n.d.].)

Weigle, Marta. "Introduction: The Penitente Brotherhood in Northern New Mexico in the Late Nineteenth and Early Twentieth Centuries." In William Wroth, *Images of Penance, Images of Mercy: Southwestern 'Santos' in the Late Nineteenth Century*, pp. 55-62. Norman and London: University of Oklahoma Press for The Taylor Museum for Southwestern Studies of the Colorado Springs Fine Arts Center, 1991. (Includes extensive quotations from both Reyes N. Martínez and Cleofas M. Jaramillo.)

Mosley, May Price (1891-1970): NMFWP, April-December 1936. According to Mosley's daughter, Martha Downer Ellis's foreword to *"Little Texas" Beginnings*, primarily a collection of her mother's NMFWP pieces, May Price was born in Midland, Texas, in 1891 and grew up on ranches in west Texas and eastern New Mexico. Educated at home, "a year or so boarding in Midland, a little at Knowles, and . . . one year at Western College in Artesia, New Mexico," she married Benton H. Mosley, "son of an early merchant at Knowles, New Mexico [in 1917], and they engaged in the ranching business in Lea County most of their lives" (p. vi). Mosley died in Portales in August 1970 and is buried in Lovington Cemetery.

According to her NMFWP "Biography" (1 June 1936; A#21:208; LCms#6), written when she lived in Lovington: "Born in Midland Texas, eldest daughter of Mr. and Mrs. Eugene H. Price, who at that time made their home on the Quinn ranch in Terry County, Texas. Mrs. Mosley was the only child in that county for some time, and her mother [Lily Kirby] often the only woman. The family first moved into what is now Lea County (N. Mex.) in 1896, moving to the old E Ranch, which was located some twenty miles northeast of where Lovington now is; and since that date this section has been home to her most of the time. 'Education,' writes Mrs. Mosley, 'in those days and circumstances, was necessarily a very fragmentary affair and mine acquired by an especially patchy process.' She learned her letters reading the various brands on cattle that drank at the ranch water trough during open range. Later, her parents usually managed to sandwich in a year's schooling (far away

from home) for her between each year of home study. So much alone-ness made of her an omnivorous reader, and so much reading seems early to have given her the desire to put the drama of life into written words. 'Leisure,' she declares, 'was the only thing on the ranch of which there was plenty.' She had two years at a freshwater college, but spent most of her time there on music. She is married and spends her time as do most housewives, save that she often substitutes study for parties, and for pastime prefers piecing colorful words into paragraphs rather than gay scraps into patchwork quilts. 'The only thorn on the rose of writing for pleasure,' she writes, 'is the alone-ness of the game; just like sol: no partners—and so much happens, while you write, that you are left out of.' Due to early environment, she declares, she will always be instinctively a little afraid of people—interesting as she finds them—and feels much freer with animals, of which she and her husband are equally fond."

Selected References

Mosley, May Price. *"Little Texas" Beginnings in Southeastern New Mexico*, ed. Martha Downer Ellis. Roswell, New Mexico: Hall-Poorbaugh Press, 1973.

Price, Eugene H. *Open Range Ranching on the South Plains in the 1890's.* N.p.: Clarendon Press, 1967.

Thorp, Annette Hesch: NMWP, September 1940-July 1941. Widow of N. H. (Jack) Thorp, living in Santa Fe while working on the WP, interviewing old Hispanic women for a collection of life stories to have been entitled "Some New Mexico Grandmothers." Born of an Austrian father who was a sheep rancher near Palma, New Mexico, and an Irish mother, Annette Hesch married Jack Thorp on December 22, 1903.

Selected Reference

Weigle, Marta. " 'Some New Mexico Grandmothers': A Note on the WPA Writers' Program in New Mexico." In *Hispanic Arts and Ethnohistory in the Southwest: New Papers Inspired by the Work of E. Boyd*, ed. Marta Weigle with Claudia Larcombe and Samuel Larcombe, pp. 93-102. Santa Fe: Ancient City Press; Albuquerque: University of New Mexico Press, 1983.

Thorp, Nathan Howard ("Cowboy Jack") (1867-1940):
NMFWP, NMWP, February 1936-August 1939, briefly afterward. According to Peter White and Mary Ann White's introduction to *"Along the Rio Grande"* (1988:2-3): "One fact that probably nagged at Jack Thorp his entire life was that he had been born in the East on June 10, 1867, into a family headed by a well-to-do New York City lawyer and real estate investor who also owned a home in Newport, Rhode Island. The youngest of three sons, Jack was reportedly sent to Saint Paul's School in Concord, New Hampshire; learned to ride and play polo; possibly attended Harvard from 1883 to 1886; and spent summers on his brother's ranch in Nebraska. At the age of nineteen, when his father suffered financial losses, Jack moved to Nebraska and then to New Mexico, where he raised and trained ponies which he rode in New York during the polo season. During this same time, 1886 to 1889, Thorp worked as a cowboy for the Bar W Ranch in Lincoln County, New Mexico. He continued to return East periodically until 1894, when his mother died

"Thorp worked as a civil engineer for the Enterprise Mining Company in Kingston, New Mexico (1890-93); operated a ranch under the /SW brand in the San Andreas Mountains (1893); journeyed to the Northwest in an attempt to take part in the Klondike Gold Rush (1897); and then contracted with a railroad company to work in Peru, but instead found himself shoveling coal on a steamship headed back to the West Coast after the collapse of the South America venture. On December 22, 1903, he married Annette Hesch, whom he called 'Blarney' because of her part-Irish ancestry, and they raised cattle and sheep in Palma, New Mexico. From 1913 until 1918, Thorp served as a cattle inspector for the state of New Mexico, tried his hand at writing, and continued to collect cowboy songs." The Thorps lived in Santa Fe during the 1920s and early 1930s. In 1935 they moved to Alameda, where Jack Thorp died on June 4, 1940.

Selected References

Thorp, N. Howard (Jack), in collaboration with Neil M. Clark. *Pardner of the Wind: Story of the Southwestern Cowboy.* Caldwell, Idaho: The Caxton Printers, Ltd., 1941. Reprinted, Lincoln and London: University of Nebraska Press, 1977.

Thorp, N. Howard. *Songs of the Cowboys.* Estancia, New Mexico: News Print Shop, 1908. Reprinted with an introduction, variants, commentary, notes, and a lexicon by Austin E. and Alta S. Fife, New York: Bramhall House of Clarkson N. Potter, 1966.

Thorp, N. Howard ("Jack"). *Songs of the Cowboys.* Boston and New York: Houghton Mifflin, 1921. Reprinted with a foreword by Guy Logsdon, Lincoln and London: University of Nebraska Press, 1984.

Thorp, N. H. (Jack), *Tales of the Chuck Wagon.* Santa Fe, New Mexico, 1926.

White, Peter, and Mary Ann White, eds. *"Along the Rio Grande": Cowboy Jack Thorp's New Mexico.* The New Deal and Folk Culture Series. Santa Fe: Ancient City Press, 1988.

Vaden, Clay W.: NMFWP, March-December 1936. Of Quemado.

THE NEW MEXICO
NEW DEAL PROJECTS:
A SELECTED, ANNOTATED
BIBLIOGRAPHY

Brown, Lorin W., with Charles L. Briggs and Marta Weigle. 1978. *Hispano Folklife of New Mexico: The Lorin W. Brown Federal Writers' Project Manuscripts.* Albuquerque: University of New Mexico Press.

A collection of the better part of Brown's 125, then known manuscripts. Biography of Brown, ethnohistory of Córdova, materials on the NMFWP and Hispano folklife in New Mexico, listing of "The Basic Corpus of Lorin W. Brown's Manuscripts" (pp. 259-64).

Coke, Van Deren. 1979. *Photography in New Mexico: From the Daguerreotype to the Present.* Albuquerque: University of New Mexico Press.

Overview with 102 plates. Chapter 5, "The Farm Security Administration and Office of War Information Photographers" (pp. 30-31).

Córdova, Lorenzo de [pseud. Lorin W. Brown]. 1972. *Echoes of the Flute.* Santa Fe: Ancient City Press. 1971 essay, "Echoes of the Flute"; two slightly revised NMFWP/WP pieces, "Lent in Córdova" (n.d.) and "The Wake" (9 April 1937); notes, place names and glossary compiled by Marta Weigle; illustrations by Eliseo Rodriguez.

Deutsch, Sarah. 1987. *No Separate Refuge: Culture, Class, and Gender on an Anglo-Hispanic Frontier in the American Southwest, 1880-1940.* New York: Oxford University Press.

Historical study of upper Rio Grande valley Hispanic villages, southern Colorado mining communities and northern Colorado sugar-beet areas. Includes "The Depression, Government Intervention, and the Survival of the Regional Community" (pp. 162-99).

Fleischhauer, Carl, and Beverly W. Bannan, eds., with essays by Lawrence W. Levine and Alan Trachtenberg. 1988. *Documenting America, 1935-1943.* Berkeley: University of California Press in association with The Library of Congress.

Fifteen photographic series, "vignettes of life in the United States between 1935 and 1943," from the 77,000 prints in the Library of Congress collection, which is well detailed in a valuable appendix. "Because each series represents one photographer's coverage during a single assignment, the series also portray the photographers at work" (p. vii). Eighteen images of "The Juan Lopez Family," taken in Las Trampas by John Collier, Jr., in January 1943, are reproduced and discussed (pp. 294-311).

Forrest, Suzanne. 1989. *The Preservation of the Village: New Mexico's Hispanics and the New Deal.* New Mexico Land Grant Series. Albuquerque: University of New Mexico Press. Important historical study setting the northern villages in regional and national perspective. Photos; valuable bibliographic essay (pp. 229-39).

Ganzel, Bill. 1984. *Dust Bowl Descent.* Lincoln: University of Nebraska Press.

Between 1974 and the early 1980s, Ganzel rephotographed many of the FSA-photographed people and places and interviewed local people for a traveling museum exhibit. Includes Pie Town (pp. 80-87).

Hurley, F. Jack. 1983. "Pie Town, N.M., 1940." *American Photographer* 10, 3 (March): 76-85.

Jaramillo, Cleofas M. 1941. *Shadows of the Past (Sombras del pasado).* Santa Fe: Seton Village Press. (Reprint, Santa Fe: Ancient City Press, 1972, 1980.)

History of the Martinez family; Hispano folklife in Arroyo Hondo and Taos County.

Jensen, Joan M. 1991. *Promise to the Land: Essays on Rural Women.* Albuquerque: University of New Mexico Press.

Introduction on "Rural Women in American History" and 16 articles, including "New Mexico Farm Women, 1900-1940" (pp. 83-96) and "Crossing Ethnic Barriers in the Southwest: Women's Agricultural Extension Education, 1914-1940" (pp. 220-30).

Jensen, Joan M., and Darlis Miller, eds. 1986. *New*

Mexico Women: Intercultural Perspectives. Albuquerque: University of New Mexico Press.
Ground-breaking collection of 13 articles, 3 appendixes. See especially two by Joan M. Jensen: "Canning Comes to New Mexico: Women and the Agricultural Extension Service, 1914-1940" (pp. 201-26) and " 'I've Worked, I'm Not Afraid of Work': Farm Women in New Mexico, 1920-1940" (pp. 227-55).

Lee, Russell. 1941. "Pie Town, New Mexico." *U.S. Camera* 4, 4 (October): 39-54, 88-89, 106-107.

Lee, Russell. 1980. "Pie Town." *Creative Camera* 193/194 (July-August): 246-53.

Mosley, May Price. 1973. *"Little Texas" Beginnings in Southeastern New Mexico*. Roswell, New Mexico: Hall-Poorbaugh Press. A collection of 20 pieces about Lea County, most of them submitted to the NMFWP in 1936, edited by Mosley's daughter, Martha Downer Ellis.

Reid, J. T. 1946. *It Happened in Taos*. Albuquerque: University of New Mexico Press.
Detailed report and evaluation of the Taos County Project, "an experiment in cooperative county planning and action," 1940-43. Photos by Irving Rusinow.

Schackel, Sandra. 1992. *Social Housekeepers: Women Shaping Public Policy in New Mexico, 1920-1940*. Albuquerque: University of New Mexico Press.
Historical study, including " 'The Women Are Not Getting a Square Deal': Women and the New Deal" (pp. 141-62).

Weigle, Marta, ed. 1975. *Hispanic Villages of Northern New Mexico: A Reprint of Volume II of The 1935 Tewa Basin Study, with Supplementary Materials*. Santa Fe: The Lightning Tree-Jene Lyon, Publisher.
Field study of Indian and Hispanic communities in the north-central, "V-shaped" basin of the Rio Grande and Rio Chama between the Sangre de Cristo and the Jemez Mountains, conducted by the Indian Land Research Unit of the Office of Indian Affairs between March and July 1935. Also included is "Sharecropping with Sheep" (1935), "Handling of a Cash Crop (Chili)" (1937), photos, notes and a 526-item, annotated bibliography through 1972, with an unannotated addendum bringing it to 609 entries through fall 1974.

Weigle, Marta. 1983. " 'Some New Mexico Grandmothers': A Note on the WPA Writers' Program

in New Mexico." In *Hispanic Arts and Ethnohistory in the Southwest: New Papers Inspired by the Work of E. Boyd*, ed. Marta Weigle with Claudia Larcombe and Samuel Larcombe, pp. 93-102. Santa Fe: Ancient City Press; Albuquerque: University of New Mexico Press.
Brief history of the NMWP; notes on Annette Hesch Thorp and an annotated inventory of her 22 manuscripts for "Some New Mexico Grandmothers."

Weigle, Marta, ed. 1985. *New Mexicans in Cameo and Camera: New Deal Documentation of Twentieth-Century Lives*. Albuquerque: University of New Mexico Press.
Photographs, life and oral histories, and descriptive accounts from various New Deal projects, primarily the FSA and Writers' Project/Program files. The representative texts and photos are arranged geographically and include Las Trampas (pp. 7-8), Pie Town (pp. 70-75), and the Moreno Valley (pp. 111, 114, 121). Appended are biographical sketches of the project workers, a glossary of New Deal projects and a selected bibliography.

Weigle, Marta, ed. 1987. *Two Guadalupes: Hispanic Legends and Magic Tales from Northern New Mexico*. The New Deal and Folk Culture Series. Santa Fe: Ancient City Press.
Legends collected by Lorin W. Brown in Córdova and magic tales collected by Bright Lynn in Las Vegas for the NMFWP. Includes a portfolio: "San José de Gracia Church, Las Trampas, New Mexico, as photographed in 1940 by Russell Lee and in 1943 by John Collier, Jr., for the Farm Security Administration" (pp. 21-32).

Weigle, Marta. 1989. "Finding the 'True America': Ethnic Tourism in New Mexico During the New Deal." In *Folklife Annual 88-89*, ed. James Hardin and Alan Jabbour, pp. 58-73. Washington, D.C.: American Folklife Center at The Library of Congress.
Discussion of the American Guide and the folklore projects of the NMFWP/WP.

Weigle, Marta, and Kyle Fiore, eds. 1982. *New Mexico Artists and Writers: A Celebration, 1940*. Santa Fe: Ancient City Press.
Facsimile reprint of "Prominent Artists and Writers of New Mexico," a special 38-page edition of *The Santa Fe New Mexican*, June 26,

1940. Biographies, photos and/or works by 150 artists and writers; introduction by Edgar Lee Hewett. Supplemented with 6 pages of photos, maps, descriptions of Santa Fe, Taos, Albuquerque, Coronado Cuarto Centennial in 1940.

Weigle, Marta, and Peter White. 1988. *The Lore of New Mexico.* Albuquerque: University of New Mexico Press.
State folklore from three perspectives: symbolic/thematic, generic and folklife (place, person, celebration). The unofficial terminus of this basically historical study is 1945; many of the 250 or so photographs are from the FSA collection, and examples from NMFWP/WP texts provide much data.

Weigle, Marta, with Mary Powell. 1982. "From Alice Corbin's 'Lines Mumbled in Sleep' to 'Eufemia's Sopapillas': Women and the Federal Writers' Project in New Mexico." *New America: A Journal of American and Southwestern Culture* 4, 3 (1982): 54-76.
Brief history; biographical sketches of the Santa Fe coordinators and the field writers; a selection of manuscripts on women.

White, Peter, and Mary Ann White, eds. 1988. *"Along the Rio Grande": Cowboy Jack Thorp's New Mexico.* The New Deal and Folk Culture Series. Santa Fe: Ancient City Press.
N. Howard ("Cowboy Jack") Thorp's NMFWP (1936-39) manuscripts on cattle culture, lost mines, local characters and outlaws. Includes two portfolios of FSA images: ranching in the Moreno Valley (pp. 64-69); rodeos at Wagon Mound and Quemado (pp. 202-10).

Wood, Nancy. 1989. *Heartland New Mexico: Photographs from the Farm Security Administration, 1935-1943.* Albuquerque: University of New Mexico Press.
Wood, who worked with Roy Stryker before his death in 1975, also consulted with Russell Lee before his death in 1986 and with John Collier, Jr., about the 5000 or so New Mexico FSA images. Interviews with Father Walter Cassidy in Albuquerque, March 1987, and residents of Mills, Springer and Bosque Farms (February-March 1987), Pie Town (1985-86) and Las Trampas, Rodarte and Taos County (February-April 1987) form the basis for three chapters on the times and the people photographed: Dust Bowl & Resettlement; Pie Town; Hispanic Villages.

Workers of the Writers' Program of the Work Projects Administration in the State of New Mexico, comps. 1940. *New Mexico: A Guide to the Colorful State.* New York: Hastings House.
Essays on land, history, peoples and cultures of the state; guides to Albuquerque, Santa Fe and Taos; 25 automobile tours covering all sections of the state. Minor revisions were made in 1953 and 1962. It has been completely redone as *New Mexico: A New Guide to the Colorful State*, by Lance Chilton, Katherine Chilton, Polly E. Arango, James Dudley, Nancy Neary and Patricia Stelzner (Albuquerque: University of New Mexico Press, 1984). The original 1940 edition has been reissued, with a new foreword by Marc Simmons, as *The WPA Guide to 1930s New Mexico* (Tucson: University of Arizona Press, 1989).

Wroth, William. 1983. "New Hope in Hard Times: Hispanic Crafts Are Revived During Troubled Years." *El Palacio* 89, 2 (Summer): 23-31.
Primarily the role of Brice H. Sewell, Supervisor of Trade and Industrial Education for the State Department of Vocational Education, in reviving crafts in vocational training schools during the 1930s.

Wroth, William, ed. 1985. *Russell Lee's FSA Photographs of Chamisal and Peñasco, New Mexico.* The New Deal and Folk Culture Series. Santa Fe: Ancient City Press and Colorado Springs, Colorado: Taylor Museum of the Colorado Springs Fine Arts Center.
Eighty-six of the 250 photographs taken by Lee in July 1940, divided into sections on the villages, farming, adobe construction, handicrafts, domestic scenes and activities, the outside world and religion. Two essays: Charles L. Briggs, who interviewed villagers in 1981, "Remembering the Past: Chamisal and Peñasco in 1940" (pp. 5-15); William Wroth and Alan M. Fern, " 'Taking Pictures of the History of Today': Russell Lee's Photography" (pp. 121-39).

Wroth, William, ed. 1985a. *Weaving and Colcha from the Hispanic Southwest.* Santa Fe: Ancient City Press.
Introduction by Wroth and retraced drawings from three State Department of Vocational Education bulletins: "New Mexico Colonial Embroidery" (1943), "Weaving Bulletin" (1937), and "Vegetable Dyes Bulletin" (1935).